Lessons in typography

Lessons in Typography
Must-know typographic principles presented through lessons, exercises, and examples

Jim Krause

New Riders
Find us on the Web at www.newriders.com
To report errors, please send a note to errata@peachpit.com

This book is part of the New Riders Creative Core series on design fundamentals. New Riders is an imprint of Peachpit, a division of Pearson Education.

Acquisitions Editor: Nikki Echler McDonald
Production Editor: Tracey Croom
Proofreader: Jan Seymour
Indexer: James Minkin
Cover Design and Illustrations: Jim Krause
Interior Design and Illustrations: Jim Krause

ISBN 13: 978-0133-99355-4
ISBN 10: 0-133-99355-8

9 8 7 6 5 4 3 2 1

Printed and bound in the United States of America

Lessons in typography

Must-know typographic principles
presented through lessons, exercises,
and examples

Jim Krause

TABLE OF CONTENTS

INTRODUCTION

When I was in high school there were only two things I wanted to be when I grew up—a pilot or a painter. I spent pretty much all my time either reading about airplanes or drawing and painting pictures of them. And then something unexpected came up and changed everything. I met typefaces.

It's true. I signed up for a graphic arts class with the idea of learning how to print the things I was drawing and painting, and then one day the instructor introduced the class to typefaces. And that was it. I was completely smitten and awed. I mean, to think that typefaces didn't just happen, that someone actually designed the things, that there were so many different kinds, and that such intricate and tiny works of art had always been sitting there inside every book I'd ever read and within just about every advertisement and movie title I'd ever looked at. And not only that, but that there was a certain species of

artist who actually created these alphabet designs— and another that put them to use in all kinds of logos and layouts. It blew my mind, and the more I looked into all the different styles and varieties of typefaces, and applied them to the posters, programs, and business cards I was working on in class, the more interested I became in both typography and graphic design.

So yes, it was an infatuation with typefaces that drew me into the only career I've had as an adult, and typefaces are still one of the main things that keep me as eager and interested as ever to keep going in my work as a designer.

Lessons In Typography is my sixteenth book on some aspect of design and creativity, and it's one that I've been wanting to do for a long, long time. I decided to open this book with a spread that talks about what I consider one of the most important thing designers

can cultivate to deepen and expand their typographic savvy: appreciation.

Why appreciation? It's because appreciation makes us look closer at things, and looking closer leads to greater appreciation, which makes us look even closer… and on and on and on. This is true whether you're talking about chocolate, music, cinema, fine art, or any other truly appreciation-worthy subject— typography included.

From there, *Lessons In Typography* gives readers a quick rundown of the terminology used to talk typefaces (you've got to speak the language of type if you're going to learn about it—just as you'd need to learn the language of chocolate, music, cinema, or fine art if you were going to learn deeply about any of those things). After that, the book takes the reader through subjects involving individual letters, complete words, multi-word graphics (logos, headlines, and

such), paragraphs, and page layouts. Notes toward the finer points of typographic appreciation thread their way through each of these topics, as does an emphasis on practical real-world uses of typography as it can be applied to things like logos, word graphics, and layouts.

What sort of designer is *Lessons In Typography* aimed at? All sorts, really. This book is for new designers who want to begin their study of the graphic arts with a good foundation of this all-important aspect of design, mid-level designers looking to bring their knowledge of typography to a higher and more focused level, and experi-enced professionals who are interested in refresh-ing and rebuilding their typographic awareness and competency.

Thumb through this book and one thing you'll notice right away is that there are a whole lot of visuals:

letterforms, word treatments, typographically inclined logos, page layout examples, and much more. I think most designers will enjoy this sort of presentation—as opposed to one that's overly text-heavy—since most people who make their living in the commercial arts seem to be visual learners.

And speaking of the book's many visuals, every one of them was created specifically for *Lessons In Typography*. This is an uncommon approach for a design-related book (given that nearly all books on design are compilations of preexisting logos, graphics, and layouts) but I prefer it and have used this method in all my books since it's allowed me to use imagery and examples that speak very directly to the topics I've covered and the points I've made through my books' text.

Lessons In Typography also has a number of exercises scattered throughout its pages. Whatever your level of experience and expertise, I urge you to try out these exercises (and I encourage teaching professionals to consider them as classroom projects). Each of the exercises builds on topics and ideas presented in the book and each is designed with real-world applications in mind. Feel free to follow the exercises' instructions verbatim or to reinterpret them to fit project ideas of your own. Entirely up to you.

And finally, a couple notes on certain software programs that are mentioned throughout *Lessons In Typography*. It should come as little surprise that Adobe InDesign, Illustrator, and Photoshop come up often in the pages ahead. It's not that Adobe has sponsored this book, or that I'm getting a commission every time I mention one of their products—it's just that these three programs are unquestionably *the* tools of the design trade these days and it seems clear that they'll remain so for

some time. It's assumed, then, that most readers will be familiar and functional with some or all of these products—at least those readers who are either a student or a professional of graphic design. Very few specific how-to tips about these programs are offered here, so if you're new to these programs, know that none of the uses for them mentioned in this book require much knowledge about them, and with a little help from a tutorial and/or a Help menu you should be able to follow along.

Thank you for picking up a copy of *Lessons In Typography*. I hope you enjoy this book and that its content not only makes you more appreciative of typefaces and the way they're used in works of design, but also makes you better at what you do as a designer.

Jim Krause
jimkrausedesign.com

CREATIVE CORE
BOOK**03**

Lessons In Typography is the third book in the New Riders Creative Core series.

The first book in the series, *Visual Design,* deals thoroughly with principles of aesthetics, composition, style, color, typography, and production.

The series' second title, *Color for Designers,* teaches designers to confidently select and apply colors to layouts, illustrations, graphics, and more.

CHAPTER 1

The
Terminology
of Type

APPRECIATION

It's no exaggeration to say that each letter, numeral, and punctuation mark of a well designed typeface is a self-contained picture of visual and communicative perfection. In fact, that's the whole point of an exquisitely crafted typographic character—to act as a component of an extended alphabet while also expressing itself through aesthetic ideals involving structure, shape, balance, and flow.

It's strange, then, when you think about it, how such incredible examples of beauty and function can go so completely unnoticed. Everyday readers overlook these visual gems, as do many of us who actually make our livings by offering them to the world through the logos, layouts, and websites we design.

This lack of appreciation might be considered unfortunate if it weren't so easily fixable. When you're passionate about a subject, you feel a constant need to learn more about it. As your knowledge grows, your eye for detail sharpens. This is true whether we're talking about sports, science, gardening, fly fishing, or typography.

That said, if you really want to dig deeper into the realm of typography, begin by looking closer at your letters and developing ample amounts of awe towards them.

In fact, start right here and now by taking a good look at the lowercase g opposite. The letter was borrowed from the perennially popular Baskerville family of type (designed over 250 years ago by the Englishman John Baskerville), and its form perfectly exemplifies the sublime qualities of aesthetic perfection that can be embodied in a letterform. Go ahead and look. Follow the letter's curves and forms carefully with your designer's eye and note their grace, variety, and flow. Spend some time here: Believe it or not, there's a lot to see and learn from a single, solitary, ravishingly beautiful, and sublimely expressive lowercase g.

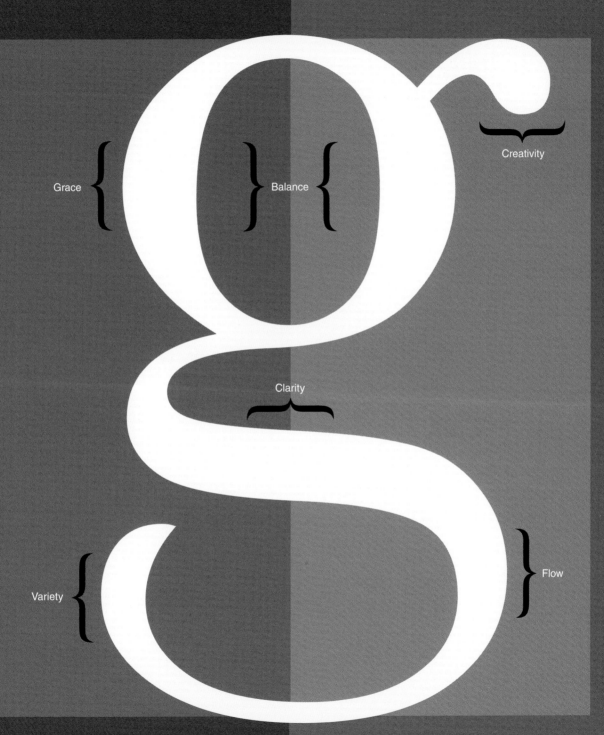

Grace {

Balance }{

Creativity

Clarity }

13

Variety {

Flow }

TYPOGRAPHIC TERMS

Do you know the difference between a Presta and a Schrader, a clincher and a sew-up, a crank arm and a bottom bracket, or a peloton and a breakaway? You would if you were a bicycle racer or a diehard fan of competitive cycling. To master any skill, you first need to learn to speak its language.

What makes topic-specific vocabulary so important? For one thing, it gives your brain a handy set of labels to apply to what you see and are interacting with as you involve yourself in anything new. Shared terminology can also prove invaluable when it comes to studying or talking with others about any subject of interest.

Though you probably knew this already, it's worth stressing since it's a temptation for even the most eager learners to want to skip terminology and technical details in favor of going straight to things like visual examples and hands-on exploration. Advice: Spend some quality time in this chapter before moving on to those ahead. That way, you'll be better able to understand, evaluate, and make use of the upcoming visuals, exercises, and text.

Let's begin our discussion of typographic terms by clarifying how a couple of all-important words are used in this book: *typeface* and *font*. There is much debate and dissent concerning the true use and meaning of these two words, but in this book the definitions are as follows. *Typeface* is the umbrella term for an overall typographic design—including each of its light, medium, or heavy weights, its italicized versions, and its condensed or extended alternatives. A *font* is a specific incarnation of a typeface. So, for example, Garamond is typeface and Garamond Bold Italic is a font.

14

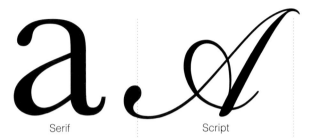

Serif

Script

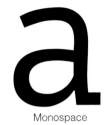

Monospace

Novelty

Sans serif

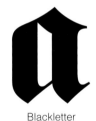

Blackletter

Display

Dingbat

Types of type

Serif faces are defined—naturally enough—by the serifs they exhibit (see the next page for a visual of what a serif is).

Sans serif literally means *without serifs*.

Specifics about each of the classifications of type shown on this page are covered beginning on page 22.

Script typefaces generally mimic cursive letters that have been drawn with a quill or a metal-nibbed ink pen.

Blackletter (also sometimes called Gothic or Old English) typefaces are designed according to the heavy, angular, and condensed calligraphic method of writing prevalent during the 13th through 15th centuries.

All the characters of a mono-space font fit within the same horizontal measurement. These fonts were chiefly developed for typewriters, and were also used with early computers.

Display typefaces come in a wide variety and are mainly used to attract attention or exhibit a specific mood.

Novelty fonts, simply put, are those that don't seem to fit squarely into any other category of type.

Dingbat (sometimes referred to as ornament, symbol, or pictorial) fonts are collections of decorations, symbols, and/or imagery. Digital media has allowed these kinds of fonts to proliferate.

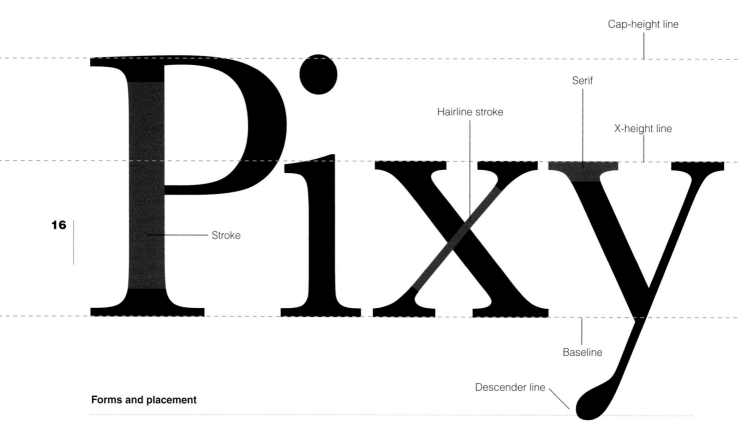

Cap-height line

Serif

Hairline stroke

X-height line

Stroke

Baseline

Descender line

16

Forms and placement

As mentioned on page 14, regardless of the subject, you need to gain an understanding of a subject's language before reaching for true proficiency and understanding. Typography is no exception. The good news here is that most of the words used to describe the details of letterforms—and the invisible guidelines within which they appear—are self-explanatory and intuitive.

Above is a labeled diagram showing the major components of a typical serif typeface, and also the upper, lower, and mid-level guidelines used to establish the placement of letters. These are fundamental and essential descriptors of typography,

and these terms—as well as most of those featured opposite—can be found throughout this book's text and captions. Get to know these words and start using them both in your brain and with others when thinking and talking type.* When you're ready, and if you like, test your knowledge of the typographic terms presented on this spread by taking the vocabulary quiz on pages 20–21.

*A full glossary of typographic and design-related terms appears at the end of the book, beginning on page 224.

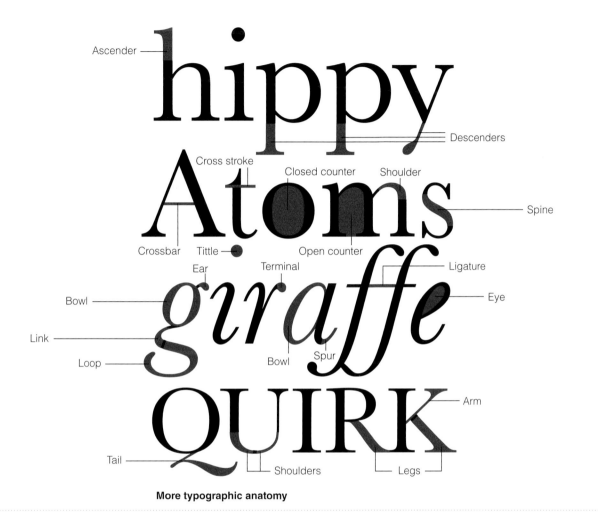

Ascender · Descenders · Cross stroke · Closed counter · Shoulder · Spine · Crossbar · Tittle · Open counter · Ear · Terminal · Ligature · Bowl · Eye · Link · Loop · Bowl · Spur · Arm · Tail · Shoulders · Legs

More typographic anatomy

The labels presented above—along with those featured on the previous page—cover just about every component of any typographic character you're likely to come across. Knowledge of these structural designations will not only help you evaluate and talk about the anatomical specifics of letterforms, it'll also help you discern differences between similar fonts by pointing you toward the details that are most likely to vary between them. These differences may be difficult to spot at first, but they should become increasingly apparent the more time you spend looking closely at typefaces.

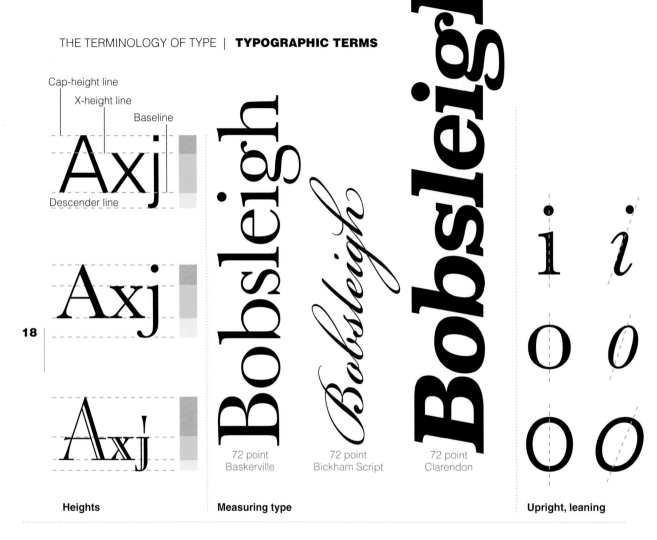

Cap-height line
X-height line
Baseline
Descender line

72 point
Baskerville

72 point
Bickham Script

72 point
Clarendon

18

Heights

Measuring type

Upright, leaning

A font's appearance and functionality are greatly affected by the way its inner guidelines are distributed between its upper and lower extremes.

Fonts are measured in points, and there are 72 points in an inch. But it's a little more complicated than that. Typeset letters were originally cast on small blocks of metal, and a font's point size was determined by the height of the metal block needed to contain any of the font's characters—including those that had ascenders or descenders. That being the case, the measurement of a font was established as the distance from its descender line to its cap-height line.

Typefaces are similarly measured today—from descender line to cap-height line—and, as you can see above, this means that fonts of a specified point size might appear notably larger or smaller than other fonts of the same size.

Complete serif and sans serif type families usually include alphabets based on both upright and leaning letterforms. Upright letters are referred to as *roman* characters, and leaning letters are referred to as *italic* (with serif fonts) or *oblique* (in the case of sans serif).

XOM

Typographic optics

It's important to know that a font's cap-height, x-height, baseline, and descender line are meant to be used as *optical* guides for the letters they support. This means that curved letterforms will generally extend slightly past these lines to compensate for the eye's tendency to view curved shapes as being a little smaller than they really are.

When you look very closely at the letters of many fonts, you'll find that other details take eyeball perception into account as well. The lower inner spaces of the capital M shown above, for example, may appear to be composed of straight lines, but closer inspection reveals that the outer lines of these inner spaces actually bend slightly outward. This is because true vertical lines would create the impression that the character's interior spaces were closing off too abruptly at their peaks. These are just two illustrations of the many perception-related subtleties typeface designers have learned to take into account when developing letterforms.

Take the quiz

Here's your chance to
test your knowledge
of typographic terms.
The instructions are
simple: Get a piece
of paper and write
the correct term for
each of the eighteen
typographic features
highlighted and numbered
on this spread.*

20

Once you're able to quickly identify letterform
components, you'll find it much easier not only to
communicate with others about typographic matters
but also to analyze and remember what you come
across when looking at different styles of type.

*Answers for this quiz are provided on page 239.

5

6

4

3

10

11

12

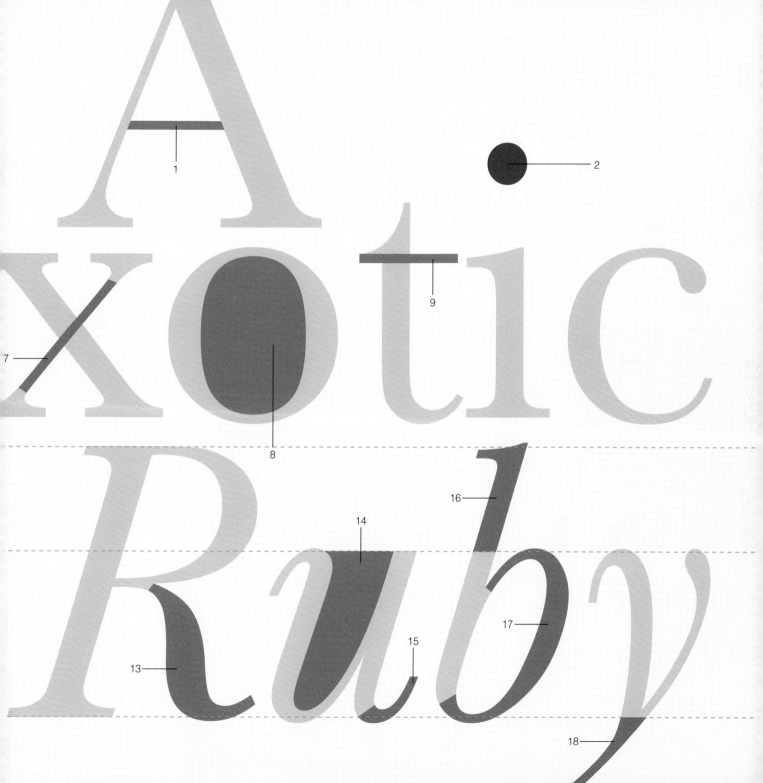

KINDS OF TYPE

If you read enough books on typography, you'll notice that the only agreed-upon essential categories of type are serif, sans serif, and script. Apart from these classifications, different designers seem to have many different opinions about how to define the boundaries between the remaining kinds of typefaces, and what to call the categories in which they should be placed.

With full acknowledgment that other books on the subject may have dissimilar ways of dividing families of type, *Lessons in Typography* places all of its typefaces into the eight categories first mentioned on page 15: serif, sans serif, script, blackletter, monospace, display, novelty, and dingbat.

Some of these divisions have several sub-categories. Serif fonts, for example, can be broken down into the four classes shown on the opposite page, and the script category—in addition to the expected traditional cursive letterforms of this genre—also includes typefaces that reflect a calligraphic heritage as well as those that appear to have been rendered in a casual manner using a brush, pen, or pencil.

The following twelve pages feature fonts from all eight of this book's categories of type—but only a few samples. The number of actual typefaces within each of these categories is vast, of course, and constantly growing. That said, don't let the sheer volume of fonts circulating these days intimidate you. Once you start spending time evaluating and working with type, and once you begin noticing which typefaces are used and loved by great designers, you'll discover a strong core of favored fonts that you can call upon for your own projects.

A A A A

Old style or humanist | Transitional | Modern | Egyptian or slab serif

a a a a

3 3 3 3

Serif typefaces

Serif typefaces are usually broken down into the four categories featured above.

Old-style serif typefaces are distinguished by rounded serifs, lesser contrast between their thick and thin strokes, and a generally softer feel than that imparted by other kinds of serif faces.

Shown above: Garamond

Transitional serif typefaces have sharp-edged serifs that taper into their strokes and a moderate amount of contrast between their thicks and thins. Serif typefaces of this kind convey little or no suggestions of the hand-drawn heritage conveyed by old-style serif fonts.

Shown above: Baskerville

Modern serif typefaces feature serifs that are straight and thin, an absence of tapering details between their serifs and strokes, and sharply contrasting weights. The visual inferences of this family of serif fonts lean far more toward the mechanical than the organic.

Shown above: Bodoni

Egyptian serif typefaces have thick, slab-like serifs that are usually tapered where they meet the rest of the letterform. Serif fonts of this class also exhibit a low level of contrast between the weights of their strokes.

Shown above: Clarendon

Tisa
Baskerville
Cooper
Cochin
Modern No. 20
TRAJAN
Lubalin Graph
Elsie
COPPERPLATE
Moraine

24

M M M
N N N
A A A
f f f f
R R R

Serifs and change

Significant details

Certain serif fonts, like Baskerville, Goudy, Garamond, and Caslon, have been around for a long time and show no signs of wearing out their welcome anytime soon. Design professionals usually have a sturdy cache of classic serif fonts like these that they turn to regularly for their logos and layouts. Other serif fonts flirt along the edges of fad and fashion, and may be wildly popular for short periods of time before disappearing into either permanent or temporary obscurity.

The recently designed Tisa typeface (seen at the top of the column, above) demonstrates a current trend toward fonts whose strong, sculpted serifs are about as weighty as their nearly uniform strokes. It's unclear, of course, how long any typographic trend will last, and whether or not it will leave permanent traces in the font menus of better designers. The only way to find out is to wait, watch, and see.

Where to look when assessing differences between serif faces? Try focusing on these features of interest: the contrast between stroke weights; the apex of the capital A; the terminal of the lowercase f and r; and the leg of the capital R.

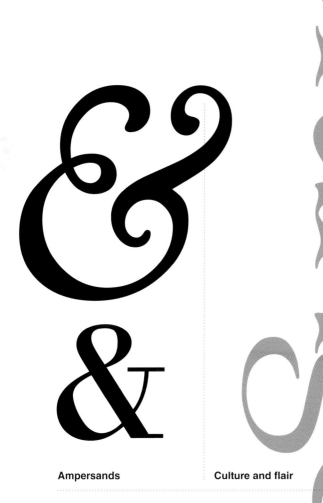

Serifs help establish
subtle horizontal cues
for the eyes to follow when
reading text. This is one
reason fonts of this kind
are often preferred for use in
books and magazine articles.

Serifs help establish
subtle horizontal cues
for the eyes to follow when
reading text. This is one
reason fonts of this kind
are often preferred for use in
books and magazine articles.

Serifs help establish
subtle horizontal cues
for the eyes to follow when
reading text. This is one
reason fonts of this kind
are often preferred for use in
books and magazine articles.

Ampersands

Culture and flair

Good for text

It's easy to get the feeling that typeface designers especially enjoy crafting ampersands. These two examples, borrowed from the Goudy and Bodoni typefaces, exude generous amounts of visual panache. Familiarize yourself with the ampersands within your font menu so you can turn to them when you're looking for a special way of saying *and*.

What gives this font (Yana) its worldly overtones of culture and exoticism? It's not the strokes of the letters, which are fairly standard serif fare, nor is it the straight-up nature of its roman letterforms. It's the exaggerated flair of its expressively curvaceous and organically rendered serifs, that's what.

Seeking ways of adding notes of far-away places to a logo or a layout you're working on—but wanting to steer clear of overtly pandering examples of faux foreign typefaces? Spend some time looking through online collections of serif fonts. Chances are, you'll find at least a few that point in just the direction you're looking for.

Serif fonts are indeed the faces of choice for most books, magazines, and other type-heavy presenters of text. See page 185 for more about the use of serif fonts for text.

Helvetica

Futura

Frutiger

Say Say Say

Helvetica	Futura	Frutiger	Panno	Klavika	Knockout
S	S	S	S	S	S
R	R	R	R	R	R
a	a	a	a	a	a
O	O	O	O	O	O

Classic sans serif

Comparing sans serif fonts

To the casual observer, there may appear little difference between various time-tested sans serif typefaces like Helvetica, Futura, and Frutiger—especially when their characters are being presented at smaller sizes. Most experienced designers, however, have made efforts to study these kinds of typefaces up close and in detail, and have learned to see and appreciate the subtle differences in how they are structured.

Some classic sans serif fonts, for example, feature slight variations in the weights of their strokes, while others embrace absolute visual consistency in this regard; some contain subtle and surprising notes of personality (as in the case of the clever serif-like spur coming from the base of Helvetica's lowercase a), while others stick to more rigorous structural conventions; and some terminate their strokes horizontally, while others terminate theirs along a vertical or a slanted axis.

Trying to spot unique structural details within a sans serif font? See whether the stroke of its S ends on a horizontal, vertical, or angled axis; determine where the leg of its R begins, where it ends, and whether or not it curves along the way; note what style of lowercase a it employs; find out if its o is a circle, an ellipse, or some other shape; and assess the overall aesthetic nature of its curves.

Panno

Klavika

House
Gothic

Reykjavik

Eurostyle

Gill Sans

Giotto

BANK
GOTHIC

Contemporary sans serif

Variety is good

The lowercase e in these three examples of newer sans serif typefaces says a lot about the thinking behind contemporary letters of this kind. Their forms are not based on circles or ellipses (as is common with many classic sans serif letterforms) but rather on variations of rectilinear shapes: The top e, above, appears as a rectangle with sides that have been bulged elliptically, and the middle and lower samples are based on rectangles that have been capped— top and bottom—with elliptical curves. Note also how the e of each sample shares visual cues with the s (and other letters as well, of course—letters that are not shown here).

The look of these fonts is both utilitarian and modern, both classic and forward-thinking. Typefaces like these have gained a strong following among designers who are looking for variations on the usual themes of Helvetica, Futura, Frutiger, Univers, and Franklin Gothic (which isn't to say that classic sans serif fonts are suddenly passé—far from it; they just have a few newcomers to compete with for use in today's media).

Resources permitting, build up your personal collection of sans serif fonts so that you'll be able to explore a strong range of options when considering sans serif typefaces of this genre for a project. Build a collection that includes designs that are classic, cutting edge, quirky, rigid, casual, tall, wide, muscular, petite, skinny, and fat.

Bickham Script

Kunstler Script

28

Edwardian Script

Lul

Mr Leopold

Lucida Calligraphy

Snell Roundhand

Zapfino

Dearest

Mr Sheppards

Cocktail Shaker

Brush Script

Hucklebuck

Script and related typefaces

True script typefaces mimic the look of cursive letters that have been hand drawn with a metal-nibbed pen. Most of today's script typefaces are either direct or indirect descendants of lettering penned by *the three Georges* of seventeenth and eighteenth century fame: George Bickham, George Shelley, and George Snell. Take a look online if you're interested in seeing examples of their work. It's not unlikely you'll be smitten, awed, and inspired by what you find.

Naturally, script fonts are well worth considering whenever you're working on projects that call for typography with a true pedigree of finery, elegance, and formality. Which isn't

to say that script fonts should be ruled out for projects with grittier thematic projections in mind: Intriguing implications of rebellion, humor, sarcasm, and tension can be generated through offbeat juxtapositions of highly refined typefaces and imagery with those of a grungier and more urban demeanor.

Offshoots of script typefaces include those that have been designed to look like modern cursive writing done with a felt or a ballpoint pen, calligraphically inspired alphabets (both neatly and crudely inscribed), and fonts that have been casually brush-rendered using a style of lettering that was popular in the early- and mid-twentieth century.

Smart scripts

A *smart* script face like Bickham Script Pro offers alternatives for most of its letters. The font automatically inserts what it thinks is the best letterform option for a given word. You can also choose specific characters through its Glyphs menu.

You might have some smart script fonts on your computer already and not even know it. Keep an eye out for instances where alternate letterforms are inserted in certain situations. If this happens, then your font may have other pleasant surprises in store for you as well.

Original

Modified

Feigned legitimacy

Some typefaces, like P22 Dearest, are capable of fooling people into believing the letters were spontaneously drawn by hand. Sharp-eyed and knowledgeable viewers, however, will notice that certain letters of words set using a face like this are identical, and will then also realize that the apparently custom and hand-crafted letters they're looking at are, in fact, typeset characters. There are a couple ways of avoiding the appearance of identical characters when using typefaces like this for logos and headlines and thereby projecting a more authentically hand-rendered feel. For one thing, you can make use of alternate characters such as the two versions of the lowercase y that are offered through P22 Dearest, and you can also convert your letters to outlines in Illustrator and make manual alterations to characters that appear more than once.

Fraktur

Duc de Berry

Lucida Blackletter

Canterbury

Blackletter typefaces

30

A B C D E F
G H I J K
L M N O P
Q R S T U V
W X Y Z

a b c d e f g h i
j k l m n o p q r
s t u v w x y z

Practicality

The Gutenberg Bible of the 1400s was printed using blackletter fonts whose characters were based on a heavy, condensed, angular style of calligraphy that arose during prior centuries.

These days, unless you happen to be working on something like a label for an authentic old-style European beer, a logo for a hard-edged goth or metal band, or a redesign of the masthead for the *New York Times*, then, chances are, a blackletter font won't be a perfect fit for your project. Still, it can be a fun (and sometimes strangely appropriate) style of lettering to consider, so keep a few typefaces of this kind in your font menu…just in case.

One challenging particular of blackletter fonts is that certain characters are surprisingly difficult to decipher when seen on their own—outside the context of a word that offers clues as to their identity. Take a look at the capital Z, above. Really? And the capitals A, G, S, and V. Good luck getting viewers of this century to understand what letters they're seeing if any of these characters are presented out of context (this, despite the fact that each of these letters has no doubt been beautifully rendered according to traditional practices). That said, simply watch out for situations where a blackletter font either hampers or destroys legibility, and be willing to make readability-improving modifications to characters or to switch to another style of type if necessary.

Joystik
Atari
dotic
MICROSCOPIC

Geneva
Chicago
New York

Andale Mono
Monaco
Courier

Monospace typefaces

Bitmap and dot matrix

The defining peculiarity of a monospace font is that each of its letters is the same width. The need for this kind of font came about with the invention of typewriters that mechanically advanced a specific amount of space after each keystroke. This means that a naturally narrow character within a monospace font, like an i, is given serif-like appendages to widen it, and an inherently extra-wide character, like an m, is squeezed horizontally. Early computers also used monospace fonts because of restrictions in on-screen resolution. There's something intriguing and attractive about monospace fonts that keeps them alive and well in the typographic scene of today, even though their time of true functionality has passed.

Typefaces that were designed for use on old-style, low-resolution computer monitors, and ones that were designed to adapt well to printing on dot matrix printers, rose in popularity from the 1960s through the 1980s. Bitmap and dot matrix fonts are rarely used for their original purposes these days, but these typefaces—as well as those that have been more recently created to mimic them—are perfectly viable for design projects that call for either literal or tongue-in-cheek inferences of technology and era (this is especially true of bitmap-style fonts whose heritage is more obvious than that of dot-matrix style fonts).

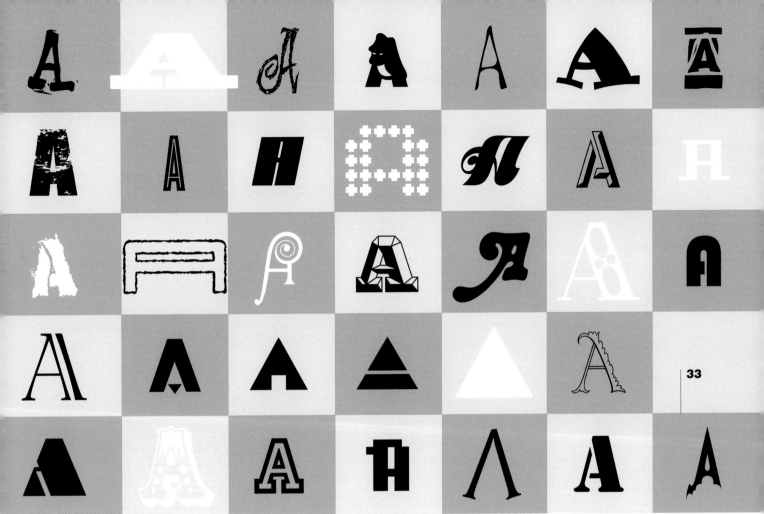

Display and novelty

Display typefaces—as their name implies—are designed to show off. Typefaces of this kind can shine when used for eye-catching, thematically flavored logos and headlines. But they can quickly become irritating when used for text. Readability is a real problem when typefaces of this sort are used at smaller sizes and for larger quantities of words.

Novelty fonts could be considered a subcategory of display typefaces, but many designers regard them as being in a class of their own simply because they appear just that much more quirky, silly, ultra modern, or deranged than a truly classic display font. If you asked ten designers which of the letters shown above are especially quirky, silly, ultra modern, or deranged, you'd probably get at least nine different answers, so it should come as no surprise that distinguishing a display font from a novelty font is anything but crisp and clear.

Display and novelty fonts are often priced very low compared to traditional serif, sans serif, or script fonts (and some are even available for free). So why not load up your computer with a nice variety of these kinds of typefaces? They might come in handy for a number of special uses including expressively designed headlines, logos, drop caps (see page 193), and word graphics.

Zapf Dingbats

Bodoni Ornaments

Wingdings

Baileywick

Big Cheese

Constructivist

Families of dingbats, ornaments, and images

A dingbat font is usually described as one that primarily holds symbols and shapes, but many people extend the definition to include fonts that contain ornamental designs and pictorial imagery as well.

A standard dingbat font (Zapf Dingbats being the most commonly known and used) holds a useful and versatile all-around collection of stars, starbursts, asterisks, flowers, snowflakes, hands, pencils, and such. Other non-letter-based fonts focus more heavily on things like decorative designs, arrows, or illustrations of one style or another.

Ornaments as add-ons and backdrops

You can use swirls, swashes, and decor from dingbat, ornament, and pictorial font families as decorative additions to letterforms when creating monograms or when dressing up a word or a sentence. Sometimes visual embellishments such as these will prove themselves ready-to-go, straight from the type menu. Other times you'll need to bring the embellishment into a program like Illustrator to make whatever adjustments and revisions are necessary to then place it with the letterform. (See page 58 for some character-customization tips.)

Need a pattern for use as a backdrop? Look through your font families of symbols and ornaments for the elements needed to create an attractive and thematically on-target design.

A B C D E F G H I J K L M N O P Q R S T U V W X Y Z a b c d e f g h i j k l m n o p q r s t u v w x y z 1 2 3 4 5 6 7 8 9 0 &

A B C D E F G H I J K L M N O P Q R S T U V W X Y Z a b c d e f g h i j k l m n o p q r s t u v w x y z 1 2 3 4 5 6 7 8 9 0 &

A B C D E F G H I J K L M N O P Q R S T U V W X Y Z a b c d e f g h i j k l m n o p q r s t u v w x y z 1 2 3 4 5 6 7 8 9 0 &

A B C D E F G H I J K L M N O P Q R S T U V W X Y Z a b c d e f g h i j k l m n o p q r s t u v w x y z 1 2 3 4 5 6 7 8 9 0 &

A B C D E F G H I J K L M N O P Q R S T U V W X Y Z a b c d e f g h i j k l m n o p q r s t u v w x y z 1 2 3 4 5 6 7 8 9 0 &

A B C D E F G H I J K L M N O P Q R S T U V W X Y Z a b c d e f g h i j k l m n o p q r s t u v w x y z 1 2 3 4 5 6 7 8 9 0 &

A B C D E F G H I J K L M N O P Q R S T U V W X Y Z a b c d e f g h i j k l m n o p q r s t u v w x y z 1 2 3 4 5 6 7 8 9 0 &

A B C D E F G H I J K L M N O P Q R S T U V W X Y Z a b c d e f g h i j k l m n o p q r s t u v w x y z 1 2 3 4 5 6 7 8 9 0 &

A B C D E F G H I J K L M N O P Q R S T U V W X Y Z a b c d e f g h i j k l m n o p q r s t u v w x y z 1 2 3 4 5 6 7 8 9 0 &

A B C D E F G H I J K L M N O P Q R S T U V W X Y Z a b c d e f g h i j k l m n o p q r s t u v w x y z 1 2 3 4 5 6 7 8 9 0 &

A B C D E F G H I J K L M N O P Q R S T U V W X Y Z a b c d e f g h i j k l m n o p q r s t u v w x y z 1 2 3 4 5 6 7 8 9 0 &

A B C D E F G H I J K L M N O P Q R S T U V W X Y Z a b c d e f g h i j k l m n o p q r s t u v w x y z 1 2 3 4 5 6 7 8 9 0 &

A B C D E F G H I J K L M N O P Q R S T U V W X Y Z a b c d e f g h i j k l m n o p q r s t u v w x y z 1 2 3 4 5 6 7 8 9 0 &

A B C D E F G H I J K L M N O P Q R S T U V W X Y Z a b c d e f g h i j k l m n o p q r s t u v w x y z 1 2 3 4 5 6 7 8 9 0 &

A B C D E F G H I J K L M N O P Q R S T U V W X Y Z a b c d e f g h i j k l m n o p q r s t u v w x y z 1 2 3 4 5 6 7 8 9 0 &

A B C D E F G H I J K L M N O P Q R S T U V W X Y Z a b c d e f g h i j k l m n o p q r s t u v w x y z 1 2 3 4 5 6 7 8 9 0 &

A B C D E F G H I J K L M N O P Q R S T U V W X Y Z a b c d e f g h i j k l m n o p q r s t u v w x y z 1 2 3 4 5 6 7 8 9 0 &

A B C D E F G H I J K L M N O P Q R S T U V W X Y Z a b c d e f g h i j k l m n o p q r s t u v w x y z 1 2 3 4 5 6 7 8 9 0 &

One typeface, many fonts

A reminder, here, that a *typeface* holds within it all the specific *fonts* of a particular typographic family, including versions that might be italic, oblique, extra light, light, medium, bold, heavy, black, condensed, extended, and more.* This page shows examples of various *fonts* of the Univers *typeface*. (Rare is the designer who consistently uses the words *font* and *typeface* with absolute accuracy, and even rarer—hopefully—are designers who are willing to pick a fight over the matter, so don't beat yourself up if you find yourself using the words inaccurately from time to time.)

A layout or a logo that calls for multiple typographic specifications might be well served by an extensively populated type family such as this. After all, visual harmony is all but assured when you're mixing and matching different fonts from within a single nicely crafted typeface. (And some typefaces, as explained on page 38, even contain fonts that belong to different categories of type.)

*Full disclosure: The *typeface vs. font* debate is actually more complex than this, but most present-day designers seem to abide by this definition when talking about typography. If you're really interested in the full scope of the *typeface vs. font* war of words, do a Web search on the subject and see what others have to say.

iffy fino fact

Ligatures

£ ¢ ¶ ∞ § º ≠ € fi fl ‡
± œ ∑ ¥ ø π « ß ∂ ©
æ Ω ≈ ç √ µ ≤ ≥ ÷ ∆
‰ Ø ∏ » Æ Ç ◊ ¿

Alternate and hidden characters

You might be surprised to find that some of your typefaces have whole sets of ligatures, special characters, symbols, and glyphs that you've never seen before. Check out the Type>Glyphs panel in InDesign or Illustrator and find out what you've been missing.

Initial Caps

lowercase

ALL CAPS

SMALL CAPS

mixed

Case

As you ponder presentation choices for headlines, logos, and type-based graphics, don't forget the important options for case applied to the word(s) you're using. Most fonts offer both uppercase and lowercase letters, some feature small-caps letterforms, and some even provide alphabets built from a mix of uppercase and lowercase characters. The computer makes it amazingly easy to try out different case options, and very often—especially when type is being configured for a logo—you'll find that certain choices offer better visual, communicative, and/or stylistic opportunities than others. (More about this on pages 84–85.)

38

Lucida Bright Regular

Lucida Bright Italic

Lucida Demibold

Lucida Demibold Italic

Lucida Standard Bold

Lucida Standard Bold Italic

Lucida Sans Regular

Lucida Sans Italic

Lucida Sans Demibold Roman

Lucida Sans Demibold Italic

Lucida Sans Typewriter Regular

Lucida Sans Typewriter Italic

Lucida Sans Typewriter Bold

Lucida Sans Typewriter Bold Oblique

Lucida Calligraphy Italic

𝕷𝖚𝖈𝖎𝖉𝖆 𝕭𝖑𝖆𝖈𝖐𝖑𝖊𝖙𝖙𝖊𝖗 𝕽𝖊𝖌𝖚𝖑𝖆𝖗

One typeface, many flavors

Traditionally, a typeface will fall into one of the eight classifications mentioned on page 22: serif, sans serif, script, blackletter, monospace, display, novelty, or dingbat. There are also typefaces that are populated by individual fonts that fit within more than one category of type.

Lucida is one such typeface, and layouts created with more than one of its fonts tend to have a cohesive look since the characters of its differently classed alphabets share subtle aesthetic similarities. Typefaces like these can make strong and versatile additions to a designer's font cache.

Embrace these five type-related habits and watch your typographic awareness grow.

Don't just look, *see*

As a designer, it's important to augment everyday routines by looking at advertisements, signage, and magazine/website features to intentionally note (and possibly identify) the specific fonts-of-interest you come across. If you see a particularly interesting printed example of type but don't have time to analyze it on the spot, snap a photo with your cell phone camera and investigate it later on.

Keep an eye on the best

As mentioned throughout this book, keep tabs on the work of great designers by looking at books, magazines, and websites that feature their work. Put this on your must-do list regularly and often.

Visit sites

There are many websites where you can purchase fonts, and many others that you can access to learn about, chat over, and admire all kinds of different fonts. Use search engines to help you find especially relevant and interesting online sources of typographic material and know-how. Bookmark these sites for repeated visits.

Know where the best stuff lives

Companies that aim to keep popular culture alive and thriving through their goods (movies, music, autos, clothing, and such) make especially determined efforts to ride the foremost edges of visual and communicative trends. This includes trends that affect design and typography, so pay special attention to— and gather design cues from—the typefaces that have been chosen to fuel our pop-culture cravings.

Geek out with other designers

This almost happens automatically in design classes and studios—the thing where students and creative professionals compare notes, exchange ideas, rant, rave, and obsess over all aspects of type. *Do this. Geek out. Absorb. Learn.*

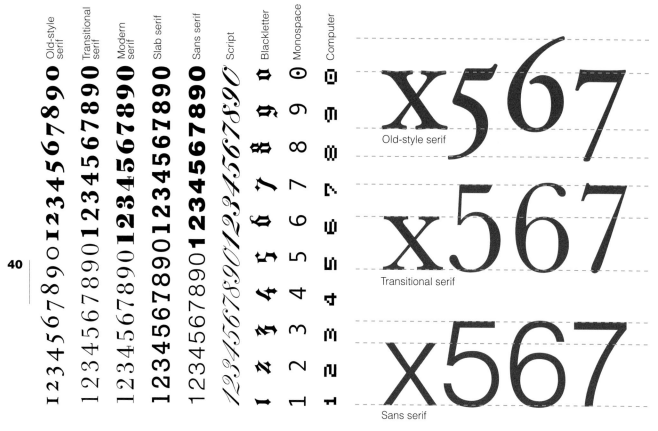

Typographic numerals

Columns (left to right): Old-style serif, Transitional serif, Modern serif, Slab serif, Sans serif, Script, Blackletter, Monospace, Computer

Right side samples: x567 — Old-style serif; x567 — Transitional serif; x567 — Sans serif

The same aesthetic and thematic characteristics that define a typeface's letters are almost always apparent in its numerals, though sometimes with a slight twist, as in the case of most old-style serif numerals—characters that flirt with baseline positions in ways that ordinary letters would rarely dream of doing.

If you're working on a logo or a headline that includes numerals, be sure to look at a variety of typeface options; sometimes two or three fonts will seem like potential winners, but only one will contain numbers that present themselves with just that something extra you're looking for—whether it be in terms of their looks or their practicality (see the column on lining and non-lining numerals on the next page).

Lining numerals

Good vertical aignments →

124
456

← *Awkward letterspacing*

Go to apartment 1601

Non-lining numerals

Awkward vertical alignments →

123
456

← *Good letterspacing*

Go to apartment 1601

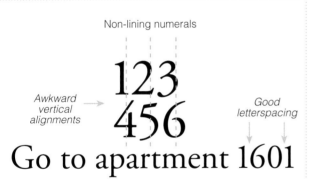

Lining and non-lining

Some typefaces feature numbers that are designed to align themselves vertically (these are called lining numerals), and some offer numbers that prioritize letterspacing over vertical alignment (known as non-lining numerals). The strengths and weakness of both kinds of numerals are illustrated above.

Note also that some typefaces offer both lining and non-lining versions of their numbers through their glyphs menu. This is a potentially handy feature, and especially worth looking into if the font you're using for a project isn't giving you the kind of numerals you want as its default.

Number options

Are you working on a logo or a headline that includes a number? If so, stop everything and take a moment to remind yourself that there are two main ways of presenting numbers: as numerals and as words. Seems obvious, right? So obvious, in fact, that it's one of those things that can be all-too-easily overlooked in the hustle and bustle of a busy design project. Be sure to consider your options in cases like these and find out if one approach offers especially compelling creative and/or aesthetic opportunities.

42

The beauty of punctuation

Not only are punctuation marks critical to good writing
and clear communication, they can also be called upon
to enhance layouts and images through both the implied
function of their forms and the aesthetic beauty of their
structure. The pair of yellow brackets featured at the far left
and right of this spread, for example, does a nice job adding
inflections of containment and connection to these pages'
assortment of punctuation-based visuals and text, while also
providing notes of visual interest to the composition.

Hanging punctuation

"This is how quotation marks align when they're allowed to hang."

Non-hanging punctuation

"This is what it looks like when quotation marks do not hang."

Hanging, or not

"Would you like more cake?" he asked.
"Maybe," she replied. Quotation marks

The strange ruler was 13.5" long. Straight quotation marks

That was an extra-hot hot dog. Dash

Refer to pages 226–239. En dash

The dog—wet and muddy—ran past. Em dash

Punctuational correctness

InDesign's Optical Margin Alignment option (available within the Type>Story menu) can be applied to paragraphs to force initial pairs of quotation marks to *hang* outside margins and thereby allow the left edge of the quoted text to vertically align. Most designers prefer this look over that produced by non-hanging quotes marks.

The typographic hints offered above may have more to do with grammar than with typography, but, as designers, we often find ourselves in the position of being the ones who need to make sure that certain conventions of proper writing are followed when we add text to layouts and Web pages.

For starters, know that there are two kinds of quote marks, curly and straight. Curly quotation marks are for quotes, and the straight ones are used to denote measurements in feet. Dashes are a little more complicated, but in short, regular dashes are used to hyphenate words, en dashes (slightly wider than regular dashes) are used between numbers, and em dashes (the widest of all) are used to establish strong breaks within the structure of a sentence.

I could have included a chapter or two about typographic history in this book, but that would have meant cutting into more relevant material: up-to-date, practical text and examples that spark real-world typographic solutions. Which isn't to say that typographic history isn't worth knowing about. Not at all. And fortunately, you can find abundant information about the historical lineage of fonts and typesetting in books and on websites. The following is a brief synopsis of typographic history—and possibly just enough to whet your appetite for more learning in this area.

The genesis of written communication began when pictographs first appeared on the walls of caves. These pictorial images were later joined by phonograms—symbols that represented the words and ideas that humans had been coming up with to talk about both physical things and abstract notions. If you were to investigate the early history of pictographs and phonograms, your study would almost inevitably lead to the Rosetta Stone—an engraved stone slab (or stele) that unlocked the secrets of many ancient engravings and texts for contemporary readers.

But long before the Rosetta Stone was created, an ancestor to the modern alphabet began taking shape: The twenty-two-character, all consonant Phoenician alphabet established itself as a primary means of communication among cultures encircling the Mediterranean Sea. One thing led to another, and the consonants of this alphabet were gradually joined by vowels that helped connect this lettering system more fully with human thought and speech. The characters of the resulting Greek, Latin, and Roman alphabets from this period can be seen to this day, inscribed in clay and stone.

Certain visual characteristics of modern typographic characters can be traced to the practice of carving or chiseling letters. Additional letterforms, and typographic details, came about during the centuries when various ways of lettering with ink on papyrus, parchment, and paper were coming of age.

44

Modern typography really began with the advent of movable type: letters molded onto small pieces of metal that could be arranged into words, and inked and printed as pages of text. Johannes Gutenberg used movable type on the letterpress he devised from an old wine press around 1450—about 40 years before Columbus sailed to the Americas. Once Gutenberg's original printing press design got upgraded for mass use and production, and once movable type became accepted as a norm—first in Europe, and then around the globe—printing technology didn't change much for the next four centuries.

The industrial transformation of the 1800s led to significant advances in print technology, making printing not only more efficient but also more affordable to the masses. The exponential growth in printing and movable type at this point in history also accelerated the development of typefaces, and stylistic variances between fonts also grew. The late 1800s saw a blossoming of decorative faces that augmented both the earlier calligraphically derived forms of lettering and the more utilitarian fonts that followed. The Art Nouveau aesthetics of the 1800s were followed by movements that had names like Art Deco, Bauhaus, Constructivism, and Swiss Style—each of which spawned families of type that are still in use today (and also still morphing in ways of their own).

Metal type gave way to phototypesetting in the mid-20th century. This technology merged with early computers, and typesetting and typefaces became that much more accessible, flexible, and varied.

The modern digital era, it could be said, pretty much blew the doors, windows, and roof off the realm of typography as it was known in previous times. Software and the personal computer have turned typeface creation into a no-holds-barred free-for-all of new ideas (many of which are based on old ideas), and have also allowed designers to use typefaces in ways that could never have been considered before—and with an ease that could only have been dreamt of.

46 CHAPTER 2

The Art
of the Letter

TYPOGRAPHIC VOICE

Letters have voices. Visual voices that deliver thematic messages like strength, fragility, elegance, angst, conformity, and rebellion. Instinctually, we know about the inference-producing qualities of type, and are affected by them both consciously and subconsciously, every time we look at letters and words that are presented through typefaces.

Designers and nondesigners alike are affected by how fonts can make us feel, but it's we—the designers of the world—who particularly need to raise our awareness of type's many moods, since it's we who are generally responsible for deciding which fonts appear before the eyes of others (and also for establishing the conceptually charged visual environments in which our words appear).

Take advantage of your computer's ability to easily swap one font for another when you're deciding which typeface speaks your message most effectively. Be willing to try out many options before deciding which is best.

48

Hear me?

Organic to digital

Tentative to emphatic

50

Luxury to squalor

Rigid to casual

Expressive range

Search hard enough and you can almost always find a typeface capable of expressing exactly the aesthetic and thematic qualities you're aiming for in the logo or layout you're working on. And not only that, but once you've zeroed in on particular stylistic and conceptual goals for your design, it's very likely you'll be able to round up a selection of fonts that lend themselves to these objectives in a variety of ways and to differing degrees.

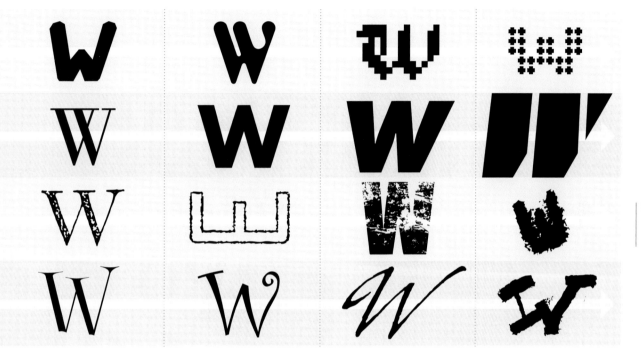

Finding a font that conveys itself perfectly for the job at hand usually means spending time scouring your font menu for typographic candidates (see page 149 for more on this). It might also involve going to the Web and conscientiously searching online font catalogs for potential winners. Investigative exploration like this can be time-consuming and tedious, but it also has the welcome side effect of exposing your eyes to all kinds of typefaces that you might never have otherwise discovered—typefaces that may or may not be suitable for what you're working on at the moment, but might turn out to be a perfect fit for a future project.

52

Artistic expression

Letters as art media? Why not? You can use typographic characters to make beautiful and expressive patterns, designs, and works of art.

Working on a letterhead, brochure, or booklet for a client? What about covering the back of the piece—or an interior panel or page—with a pattern built from their initial(s)?

Got some time on your hands on a weekend afternoon or a weekday evening? How about producing an eye-catching composition from the initials of a friend or a family member and framing it as a present for a special occasion?

Or what if you create a large-scale pattern using an assortment of typographic components and use it to print your own sheets of custom-made wrapping paper for gifts to like-minded creative pros?

Projects like this could be the perfect creative counterpoint to the usual client-based and deadline-driven work you do as a designer—and could be just the kind of thing you need to do once in a while to remind yourself of the funner aspects of design that drew you to your profession in the first place.

LETTER MODIFICATIONS

A letter borrowed from a font can be perfect and still not be perfectly suited for the monogram, logo, initial cap, or layout you're working on. For example, a letter might be structured with proportions and a weight that fill a space in just the right way but conveys the wrong feeling or mood. Or, a letter might be born with exactly the expressive feel needed for a project but be too tall, short, skinny, or heavy for the use you have in mind. What to do? How about making some modifications to the letter to help it adapt to your needs?

54

I handled most of the letter-altering treatments seen on this spread and elsewhere in this book in Illustrator, and the rest I performed using Photoshop filters and effects. Some involved the addition of custom-created decor and imagery, others made use of decorations borrowed from dingbat and ornament typefaces, and a few made use of scanned artwork from copyright-free archival sources.

Whatever kind of typographic treatment or effect you're aiming for, and however you're going about it, be sure to call upon your art sense to guide you toward your highest visual goals. And don't call it quits until you get there.

Keep in mind that it can be easy or difficult to modify letters—it all depends on how well you're able to match the modifications you have in mind with the skills that you have at your disposal. If you find yourself up against a typographic alteration that seems just out of reach, think of it as your chance to learn something new rather than seeing the situation as an obstacle. Keep at it even if it means missing an occasional coffee break or spending extra hours at your work desk every now and then: This is exactly how good designers become great designers.

Cutting and modifying

You can quickly and easily make significant changes to a letter's stylistic and thematic qualities using Illustrator's versatile set of tools and form-altering operations. With a modest amount of know-how, you can convert characters to outlines, then cut, slice, and modify their forms to match just about any outcome you can envision. Digital tools allow today's designers to deftly pull off all kinds of typographic modifications in a fraction of the time it took our predecessors to handle them using knives, pens, rulers, and ink. And not only that, designers of the digital era can also explore alternatives to any visual solution they're working toward with incredible variety and perfection. Take full advantage of the perks of digital media whenever you're working on aesthetic and structural changes to letters.

Additions and effects

On a related note, visual elements can be *added* to typographic characters in infinite ways to generate notes of expressive and/or visual interest. See more examples of this kind of thing on the next spread and on pages 69, 75–76, and 110–114.

Photoshop, too, can be used to add interesting visual effects to letterforms. The lower character in this column was blurred using Photoshop's Gaussian Blur filter, and then treated to the Enlarged Halftone effect. Are you familiar with Photoshop's huge array of filters, treatments, and special effects? If not, how about spending some time getting to know them? These days, it's almost mandatory that designers be competent users of Photoshop, Illustrator, and InDesign.

ABCDEFG

ABCDEFGH

ABCDEFG

ABCDEFGHIJK

Ready-to-go modified fonts

As noted, I altered most of the typographic characters in this chapter using Illustrator or Photoshop.

All the visually enhanced letters on this page, however, came straight from the keyboard—directly from fonts whose letters have been designed to appear customized in one way or another. Some fonts of this kind include characters that feature graceful extensions, added swashes, or built-in swirls; some exhibit form-following inner highlights (known as *inlines* and *handtooling)*; and still others have been transformed in ways that imply damage, decay, or doodling. Fonts like these might be good places to look the next time you're seeking a ready-to-go, custom-looking character for use as a monogram, initial cap, page decoration, or standalone graphic.

Decorative additions

Thematic relations

Take a moment and ponder the thinking behind each of the four decorative typographic creations shown above: One features a character that's been outlined and positioned atop an illustrated backdrop of contrasting style; another includes a heavy and bold capital figure dressed up with an interior pattern of conjoined circles and surrounded by a wispy and ornate design; one shows a capital A that's had its crossbar replaced by a decorative line that playfully threads its way around the letter's strokes before geometrically wrapping itself around the character; and the last presents a bold lowercase letterform that's been trimmed with a set of leafy extensions.

Now, consider: How could you apply the thinking behind any of these examples to a project of your own? Or better yet, what *variations* of these treatments might be pursued en route to an entirely unique visual outcome? Advice: Think in terms such as these when looking at *any* and *all* of the visual examples offered in this book as well as whenever you come across intriguing type-based visuals elsewhere.

Whenever you're mixing type with imagery, consider—at least momentarily—pairings that result in slight (or overt) clashes between thematic personas: crisp with casual, sophisticated with subversive, reserved with rowdy, maniacal with minimalistic, and so on, and so on, and so on...

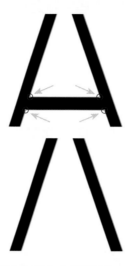

58

This demonstration outlines the steps you can follow to create a monogram featured on the previous page. This sequence of modifications illustrates several letter-altering treatments that can be applied widely to other projects. If you're familiar with Illustrator, this demo will be easy to follow. If not, you may need to learn a few Illustrator basics before coming back to it.

Above, the monogram starts out as an uppercase A from the Futura Light family. Once brought into Illustrator, convert the letter to paths at a large size (working large can make it easier to make fine adjustments as you refine a typographic design).

Use Illustrator's SCISSORS tool on each of the four attachment points that connect the letter's crossbar with the rest of the character.

Once the letter is cut at these points, delete the crossbar.

Begin work on the mono-gram's swirling decor by adding an ellipse to the document. This shape is used to guide the creation of the gracefully curving design that will become an embellishing element.

With the ellipse as a guide, use Illustrator's PEN tool to draw an ellipse-based shape with two unconnected ends. Place the ends of the design at equal distances from the design's center to keep things as symmetrical as possible.

Connect the shape to a clone of itself.

A procedure like this—though very simple—may require making minor adjustments to your original shape to ensure that once it's duplicated, it joins gracefully with its clone and produces a nice looking double-ellipse form.

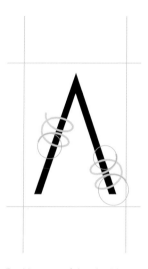 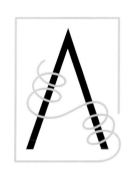 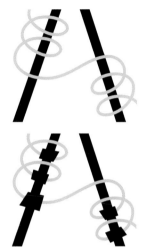 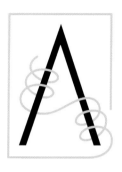

Position two of the double ellipses over the modified typographic character as shown. Adjust their weight and color as you like.

Add circular guidelines to each of the double ellipses. These will help guide the creation of a graceful connection between them in the next step.

Place horizontal and vertical guidelines where the monogram's rectangular enclosure will go, and then add one more circular guideline to help you draw connection between the lower double ellipse and the enclosure.

Use the PEN tool to finish and fine-tune the monogram's swirling embellishment and its geometric enclosure.

The only thing left is to create the illusion of an over-and-under interaction between the monogram's embellishment and its character's form.

First, convert the colored line into a shape by choosing Object>Path>Outline Stroke.

Next, loosely draw the black shapes with the PEN tool wherever the swirl is meant to look like it's falling behind the character's strokes. Once drawn, cut and paste the black shapes within the colored embellishment using a clipping mask. After this is done, the black shapes will appear within the form of the colored embellishment, and the over-and-under illusion will be complete.

The finished design.

This letter-transformation involved removing a structural element from a letterform, creating a gracefully curving embellishment, connecting the embellishment with both the letter and its enclosing shape, and using a bit of digital trickery to create a dimension-implying effect.

Keep operations like these in mind when you're looking for ways of altering individual letters, and also when seeking ways of changing the look of one or more characters within a word or a group of words.

BUILDING CHARACTERS

At its highest level, typeface design is among the most exacting and detail-oriented forms of art in existence. The subtleties inherent in a classically composed serif or script font are almost beyond the comprehension of designers who haven't extensively studied the craft of typeface creation.

Still, that doesn't mean designing letterforms is beyond your reach. In fact, designers who are able to combine even basic software skills with a savvy eye for evaluation can perfectly handle creating some styles of type—and entirely valid, attractive, and usable styles at that.

Try startng with letters built from shape-based forms. In spite of the humble visual vocabulary from which these kinds of typefaces arise, there is literally no limit to the ways in which they can be constructed and detailed.

Because of their novel appearance, letters of this sort usually belong to the display or novelty categories of typefaces. Keep this in mind the next time you're working on a logo or a headline for a project that calls for the kinds of expressive qualities this style of font can offer.

This spread and the next present insights and examples related to the creation of shape-based typographic characters. See pages 66–67 for related projects you can try on your own, and also check out the samples shown on page 122, which include words that have been built using expanded sets of letters taken from the font designs initiated here.

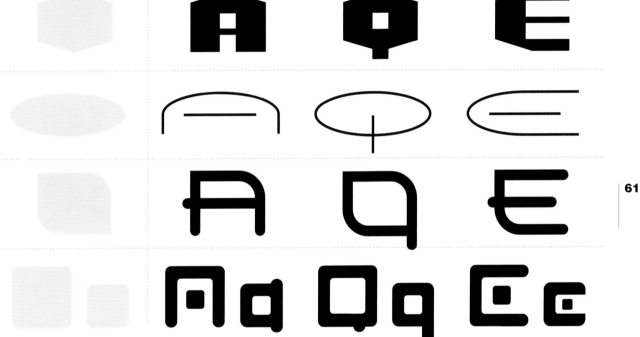

Creating within shapes

You can build interesting and potentially useful letterforms using simple geometric shapes as containers. The boundaries of these containers can be obeyed rigorously or loosely, and the letters inside them can be thick, thin, heavy, light, plain, or complex. This simple and seemingly constrained formula for typeface creation can actually lead to an unlimited variety of outcomes.

Typefaces made in this way are usually classified as display or novelty fonts. You can use these typefaces for logos and headlines that need to infer a modern or high-tech feel.

When creating shape-based letters like those featured above, explore numerous structural variations and finishing touches before deciding on their final look. Consider establishing your letters' strokes as thick, medium-width, thin, or varied; think about employing straight, angled, or curved beginnings and/ or endings to your characters' strokes; look at different ways of aligning typographic elements like the crossbar of the capital A (if your capital A even has a crossbar) and the middle horizontal stroke of the capital E (provided it has one); and see what happens when certain interior or exterior features are rendered as geometric shapes (circles, squares, triangles, stars, or other). And what about adding final details like decorations, swashes, indentations, or protrusions?

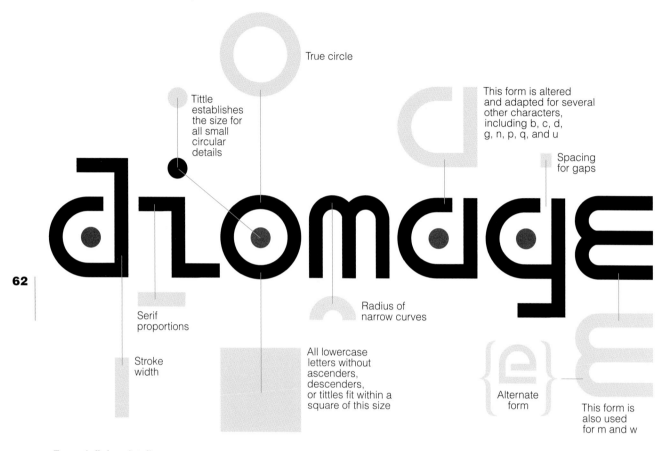

True circle

Tittle establishes the size for all small circular details

This form is altered and adapted for several other characters, including b, c, d, g, n, p, q, and u

Spacing for gaps

Serif proportions

Stroke width

Radius of narrow curves

All lowercase letters without ascenders, descenders, or tittles fit within a square of this size

Alternate form

This form is also used for m and w

Form-defining details

It's surprising how few details are actually needed to define the look of a font. The appearance of an entire alphabet's strokes, corners, connections, terminals, decor, and expressive details can be determined according to the attributes of just a half-dozen or so characters.

The letters shown above belong to a modern-looking, custom-designed monospace font. The word used to present the font is nonsensical, but it's a good choice for the development of a face's lowercase letters since it provides opportunities to confirm enough structural and stylistic cues to complete an entire set of lowercase characters. (The pseudo-word QAREMS works similarly well for capitals.)

The structural and aesthetic details inherent in the letters represented above are simple and basic compared with those seen in classic serif, sans serif, or script designs, but it's good to know that if you someday decide to delve deeply into the world of typeface creation, the idea demonstrated here—that a typeface's characteristics can be established using only a handful of letters—can also be applied to fonts whose forms are considerably more complex.

Interested in beginning a shape-based alphabet of your own? See the final exercise on page 67.

62

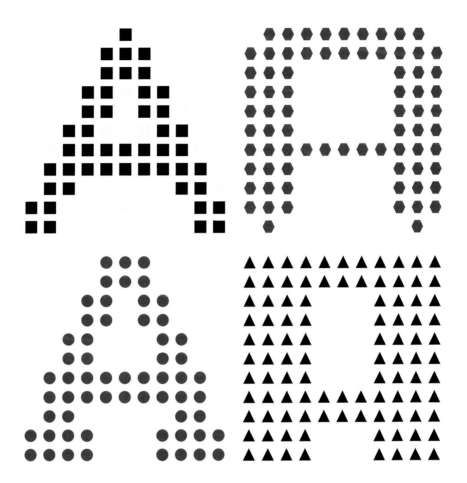

Gridded letterforms

Not only can you employ ordinary geometric shapes to help create letterforms (as illustrated on the previous two pages), you can also use them to create gridded patterns from which letters are highlighted. This variation on the bitmapped-look that defines certain digitally themed fonts can apply itself well to projects that call for letters or words that express themselves in a showy, cyber-modern way. A surprising amount of stylistic leeway is available when following this letter-building strategy. The kinds of geometric form(s) used, the shape and density of the overall grid that's employed, and the visual characteristics of the letters highlighted within that grid can vary widely—and small differences in the structural and aesthetic details of your letterforms can have a big impact on their look.

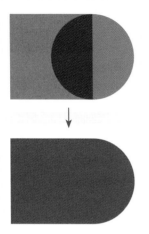 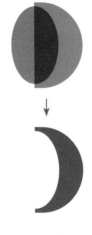

64

What happens when you merge the forms of a circle and a square? One result can be seen above, and infinite others can also be found using Illustrator's Pathfinder panel.

Among other things, the Pathfinder panel allows designers to add shapes together, subtract the form of one shape from another, and create new forms based on intersections between one or more shapes.

This is the kind of thing that can occur when the silhouette of one form is subtracted from another.

Designers involved in the creation of logos, graphics, and/or typographic characters (which probably covers 99 percent of designers out there) should really get to know the Pathfinder panel. It's a tool that can make it possible to create a wide variety of visuals with an ease, quickness, and flexibility that could never have been matched when hands-on analog tools were the only choices for art professionals.

Use multiple shapes together to affect the form of another shape. Here, four circles have been grouped, and their combined forms have been subtracted from a single square.

Once you start getting used to using the Pathfinder panel, it becomes ever easier to take images that are floating around in your head—or sketched out on a sheet of paper—and produce them on-screen through one or more Pathfinder operations.

InDesign also features a smaller set of Pathfinder tools, available through its Object menu.

You can take the results of any number of Pathfinder operations and combine them into more complex designs such as realistic renderings, abstract symbols, typographic characters, and more.

Each of the letterforms shown on the opposite page were made from Pathfinder treatments that were applied between circles, between squares, and between circles and squares. The resulting shapes were also allowed to be scaled horizontally and/or vertically en route to finalizing the letterforms.

Ready to make some letters? If you're a designer with at least a reasonably good eye for aesthetics and a copy of Illustrator (along with a basic knowledge of how to use it), then yes, you're ready. Here are four project ideas based on material borrowed from this chapter.

Slice, dice, chop, and more

This one is less like a learning exercise than it is like a learning playtime. Simply open up Illustrator, choose some favorite typefaces, and key-in a dozen or so characters that you can convert to paths and alter in different ways. Not a lot of forethought is needed for this project. This is simply your chance to change the look of letters by slicing, reshaping, bending, and/or warping their forms. Digital effects are fair game, too. Just jump right in and see what you can learn by trying out different tools, treatments, and menu options. Follow your curiosity and intuition until you've come up with a half-dozen or more custom-rendered letterforms that not only look interesting and attractive, but also convey themes of your choosing (speed, damage, grace, roughness, functionality, excess, and the like).

Extend yourself

Typeset your first name, last name, or both in Illustrator. Choose a font you love. Feature your word(s) in either uppercase, lowercase, or mixed-case characters. If you're dealing with two or more words, you may stack them or set them in a standard horizontal configuration. And here's where the real project begins: Create one or more extensions coming off one or more of the letters you're working with. The extension(s) could be long, graceful, and ornate; short, stubby, and casual, or anything in between. Your letterform addition(s) could reflect something about yourself, or could denote a tongue-in-cheek or satirical departure from your persona. Modifications may be made to other letters in your design but don't have to be. Color is welcome. A tip: Thumbnail sketches would be an excellent place to begin.

Grid work

Here's a project that starts out within very simple parameters, and can be taken into all kinds of different directions. Begin by coming up with a five-letter typeface name that has no repeated characters. Next, present your word using a font that you create according to this set of guidelines: Each of your word's letters must be highlighted in color from within a grid of shapes (as seen at top); your grid should be made up of squares, circles, ellipses, triangles, or polygons (and only one shape should be used to populate your grid); the grid should have an equal number of shapes along its top, bottom, and sides (the example above uses an 11 x 11 grid); the overall shape of your grid may be a square or a rectangle, and your characters may be styled as serif, sans serif, or any other kind of lettering.

This project may be especially interesting to do as a group exercise: It can be enlightening to see just how much variance arises when different artists work within the same seemingly tight creative parameters.

Create a lowercase foundation

Your word is *diomage* (not a real word, as mentioned on page 62, but perfect for this project, nonetheless). And your challenge is this: Create the letters for this lowercase word using your own custom-created font—a font built according to a shape-based strategy like those presented on pages 61–62. Abide by the general terms of this method of letter creation, but also feel free to expand its creative parameters as needed as you develop the look of your letters. Some advice: Use thumbnail sketches to get your ideas flowing; strive for a look of strong stylistic and structural consistency between your letterforms; shoot for uniqueness and originality; aim for an adequate degree of legibility; consider designs that have serifs as well as ones that don't; and think about adding decorative or style-establishing details to your characters. Once you're finished with this exercise, know that your set of letters will be able to provide you with enough visual and stylistic cues to complete an entire lowercase alphabet—which you're encouraged to do if you feel so inclined.

ADDING IMAGERY

Few things make a designer happier than coming up with intriguing and eye-catching visuals that meaningfully connect with viewers.

Maybe this is why so many designers get especially excited when given the chance to mix letters and imagery. After all, the potential for generating thematically charged designs by blending a font's expressive persona with both the literal and abstract implications of an image or a piece of decor is huge, vast, *and* monumental—to say the least.

You can connect illustrations, photos, decorations, and patterns with letterforms by featuring them with, connecting them to, placing them behind, or positioning them around individual letters. (Naturally, you can apply these same kinds of visual associations to words, sentences, headlines, logos, and pages of text—and examples of each of these appear in the chapters that follow.)

You can combine thematically similar letters and imagery to deliver expressions of conceptual harmony. The classic uppercase Y joined by an elegant typographic ornament at right is a good example of this kind of pairing.

You can also bring together type and images with differing stylistic personalities to generate notes of wit, rebellion, or discord (the regal capital R featured opposite, along with its conjoined writhing snake, is a fair example of an intentionally discordant association). Sometimes unlikely and quirky solutions like these can win the day when it comes to combining letters and imagery, and sometimes it's a more harmonious approach that's best. How to find out which tactic is ideal for the project you're working on? Try both through sketches and/or on-screen experimentation and let your designer's instinct make the call.

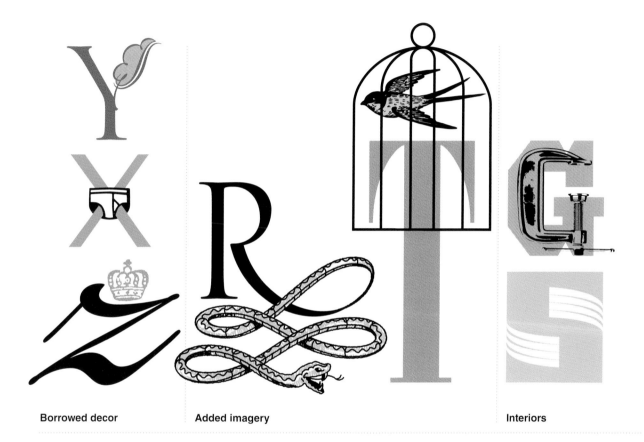

Borrowed decor

Added imagery

Interiors

The pictorial elements added to these characters were borrowed from image-based typefaces (and yes, that includes the graphic representation of a pair of undies at top). Working on a monogram, an initial cap, or a letter graphic? How about looking through a few families of dingbats, ornaments, and/or pictorial elements for visuals?

A custom-drawn or ready-to-go image can be *joined* with a a typographic character as an extension. Imagery can also be featured *along with* a letterform. Could either of these approaches apply itself effectively to a project of your own? If so, brainstorm ideas regarding font choice, illustrative content, stylistic appearance, and the overall structure of what you'd like to present. Get the ideas flowing using word lists and thumbnail sketches (pages 108–109) and resist the temptation to turn on the computer until you're relatively certain and confident of the aesthetic, stylistic, thematic, and compositional goals you'd like to reach (ignoring this advice means you risk wasting time and going down creative paths that lead to dead ends and disappointment).

How about featuring imagery within the interior of a character's form? (More ideas along these lines appear on the next spread.)

What about using abstract or representational shapes to define a letter's negative spaces?

Imagery inside

The final column of the previous page offered two ideas about placing imagery inside typographic characters. Here are five more approaches worth considering.

A letter's form can be entirely filled with an illustration, a pattern, a photograph, or a decorative design.

Closed counters, such as those seen in the capital A, B, D, O, P, Q, and R, and the lowercase a, b, d, e, g, o, p, and q of most type-faces, can also be used to hold visual matter.

The subject of an illustration or a photograph might be allowed to sprout from within—and possibly extend itself beyond—the open space within a character.

A letter's form can be blended with imagery that sits above or below it using the transparency and blending controls available through Illustrator, Photoshop, and InDesign.

Enclosure-establishing backdrops can also show themselves within the open spaces of the characters they hold. The letter in the far right example has been colored to help it stand out from its enclosure/backdrop.

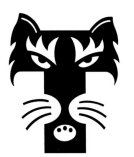

The illustrated letter

The letter as illustration

A number of off-the-shelf typefaces offer characters that are stylized or semi-realistic depictions of objects, plants, animals, and human beings. Got a few novelty faces of this kind in your cache of fonts? Every so often, they can offer a quick solution to a layout need.

Working on a single-letter monogram, initial cap, or page graphic? What about creating a custom-made illustration of your typographic character? A rendering that connects with both your piece's theme and its subject?

You can create typographic illustrations like these using digital media or traditional analog tools (as in the case of the capital K shown at right, which was created with acrylic paints and a small print-making ink roller).

Don't automatically shy away from opportunities to draw, paint, or otherwise render typographic characters for projects that call for them—even if you don't think of yourself as a competent illustrator. Nearly all designers are capable of producing eye-catching visuals using a combination of their sharp eye for evaluation and whatever illustration skills they can call their own.

MONOGRAMS AND LETTER SETS

In design, monograms are usually defined as logos and graphics built from one or more initials. Monograms can be made purely from type, they can include imagery, and they can be fashioned inside a border or set against a backdrop.

It's only natural that many companies use monograms as part of their logo since these kinds of letter-based designs connect naturally with the company's name while also conveying sought-after thematic expressions through the style and aesthetics of their presentation.

Some individuals also enjoy having a personal monogram created for use on calling cards—and on whatever else they think might be enhanced by a visual reminder of themselves.

You'll notice that some of the monograms featured here make use of existing typefaces, while others employ custom-built letterforms. Either route can work, of course, so consider both options when developing designs of this kind. (Ideas borrowed from the letter-building strategies mentioned on pages 61–62 could come in handy if you're considering creating a monogram from scratch, as could the hand-lettering advice offered on pages 125–127.)

What's the best way to begin a monogram project? Same way as you'd begin just about any other creative typographic endeavor: by identifying the feelings and ideas your creation ought to communicate (page 108); surveying the fonts available on your system and elsewhere (pages 148–149); and making thumbnail sketches of potential solutions (page 109).

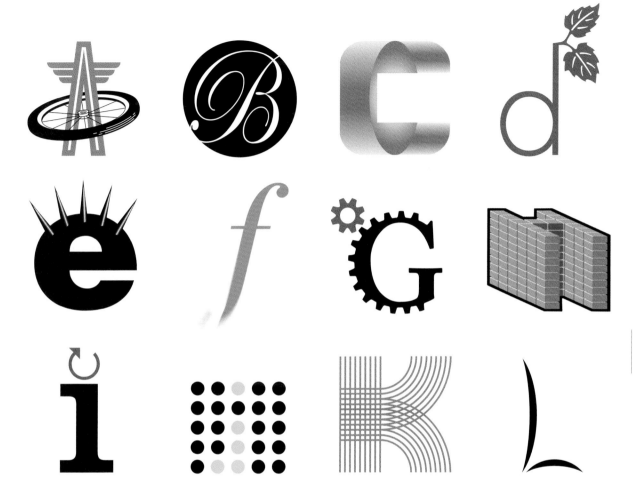

Monograms

Each of these single-letter examples has something to say about the thinking that can go into the creation of a monogram to help it deliver its aesthetic content and thematic feel.

Among other things, a monogram can be: assembled by integrating a letter with imagery; created using an existing typeface and a simple backdrop; built to resemble a dimensional form; constructed by extending an ornamental image or two from a typographic character; illustrated to include something like a hard-spiked Mohawk to playfully connote feelings of menace; enhanced using Photoshop effects; rendered in a way that depicts real-word interactions between objects; crafted to resemble an in-perspective 3D structure; devised by combining a letterform with a symbol; fabricated using a grid of shapes (see also page 63), fashioned entirely from straight and/or curved lines; or drawn from scratch using a visual vocabulary of either simple or complex forms.

You can use these aesthetic, conceptual, and structural approaches to create monograms as well as multi-letter headlines and logos (more on those kinds of applications in Chapters 3 and 4).

Pairs and sets

You can apply the same single-letter design ideas demonstrated on the previous page to multi-character monograms.

Monograms made from multiple letters also offer added opportunities for aesthetic and thematic expression because of the potential for interaction between their two or more typographic characters.

Though monograms may not always be the best or only solution for logo projects, designers often include one or two when presenting branding ideas to clients—especially if a company's initials present unique visual and conceptual design opportunities.

Legibility is important with monograms, just as it is with words. That said, a monogram can gain a certain amount of leeway in this regard when you're planning to always—or almost always—present it in conjunction with the fully spelled-out words its initials represent. For example, if the U, V, and W in the monogram above were always presented in clear association with words that begin with these three letters, it's central character would likely be understood to represent both a V and a pair of scissors (an understanding that might be lost if the monogram were *not* shown with words with corresponding initials).

AAND**Z**

A:Z **A**and**Z**

A+Z **AZ**and A--→Z

A&Z A&Z

Ways of saying *and*

Working on a logo for a company with a name that's two words with an *and* between them? Think a monogram might suit the project? If so, then spend time and effort thinking about and thumbnailing different ways of presenting the idea of *and* within your design.

Sometimes, the way *and* is conceptually and/or aesthetically handled within a monogram is precisely the thing that gives the design its extra measure of interest and appeal.

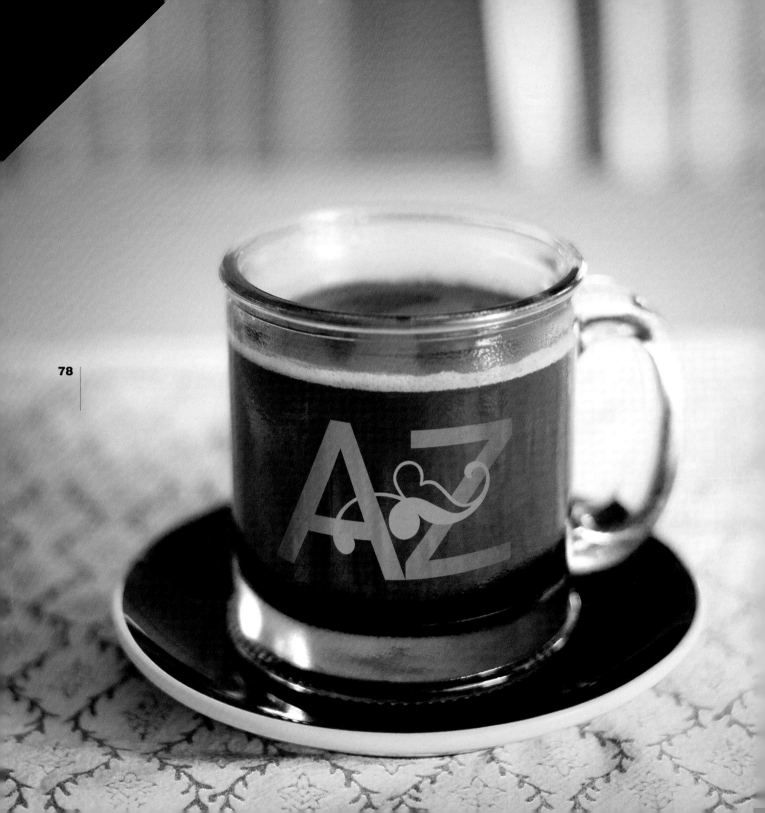

Thinking collaterally

When developing type-based logo designs for clients, keep it somewhere in the front, middle, or back of your mind that your creation will likely be used collaterally for branding opportunities involving product, vehicle, clothing, or packaging graphics.

In cases where these kinds of uses are a real possibility, it might be a good idea to create renderings or dimensional mock-ups that demonstrate your design being used in such ways. Sometimes, the presentation of these extra-dimensional visuals are just what's needed to convince a client that the design you're presenting is just the one they've been looking for.

80

One, two, or more letters

Existing typeface

Custom lettering

Letter with illustration

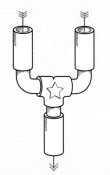

Letter as illustration

Personal monogram

Create a monogram using your initials—and conduct the entire process as though you were your own client. This will mean developing a set of three or four ideas for presentation, and then selecting your favorite for finalization. Naturally, your winning design should be something that appeals to you greatly, and also reflects aspects of yourself that you want to project through your creation. It's a great idea to begin your creative process using word lists and thumbnail sketches (see pages 108–109) before moving on to the computer for further development. Your design could be built around one, two, or more of your initials. It could be made using one or more characters taken from an existing typeface, and the character(s) could be modified, or not. The design could be made using one or more custom-crafted letters. It could include imagery or decor. The monogram could present itself in the form of one or more letter-as-illustration characters. Browse the samples presented earlier in this chapter for more in-general ideas that could be applied to your creation.

Different ways of saying *and*

Here's your task: Design a letter-based graphic that could appear at the top of a question-and-answer column in a magazine. The graphic should include the initial Q, followed by an ampersand (or the spelled-out word *and*), and then the letter A.

For instance:

Q&A

Come up with three different solutions. Each should feature different ways of handling the word *and*; each should make use of different fonts; and each should stylistically present itself differently from the others. Feel free to use color. The inclusion of minor decorative elements and/or linework is permissible but not mandatory.

CHAPTER 3

Working with Words

WORD FUNDAMENTALS

Consider these relationships when working with either letters or words: both letters and words can be typeset using existing fonts; both can be presented through modified typo-graphic characters; both can be incorporated into logos and layouts with or without additional decor, linework, backdrop panels,

or imagery; and both can be set using either upper-case or lowercase characters.

But also consider the distinctive qualities unique to working with words—as opposed to dealing with solitary letters. For starters, the designer needs to decide which case format to apply to their word, and whether or not the spacing of the word's letters needs to be adjusted in some way.

These two typographic considerations are addressed on the facing page, and the topic of letterspacing is given additional attention throughout this chapter. (Give special notice to the letterspacing tips and examples offered ahead: No matter what else a logo or headline has going in its favor, it can't be considered

properly finished if its letterspacing has been inconsistently or inappropriately applied.)

Another typographic matter that arises uniquely when working with words involves the appearance of ligatures. Ligatures are typographic figures used to solve aesthetic and structural issues when certain characters appear sequentially (see pages 37 and 87 for more about ligatures).

84

A L I Z

alizarin

ALIZARIN

Alizarin

ARIN

ALIZARIN

Font, case, and space

Once you've narrowed your search for just the right font for the logo, headline, or word graphic you're working on, and before you really get into the development of how that word will be presented (whether it'll include letter modifications and/or imagery, and how it might sit among other graphic elements if it's part of a page layout, for instance), take the time to look at your word in various configurations of case: uppercase, lowercase, and initial cap. And also see how the word comes across when it's letterspaced both loosely and tightly.

Why do this? It's because (surprisingly often, in fact) you'll discover aesthetic and structural opportunities that reveal themselves only when you apply certain case configurations and/or letterspacing solutions.

For example, you might notice an all-caps presentation of your word provides opportunities for interesting and attractive ligatures that don't come up when the word is set in lowercase; you might realize that presenting the word with an initial cap creates a unique structural opportunity for the placement of a piece of decor or imagery; or you might find that the difficult letterspacing issues that occurred when a word was set in caps disappear when its letters are presented in lowercase.

aKimbo

AKIMBO

Akimbo

AKIMBO

akimbo

Mixed specifications

Expand on the post font-selection considerations of case mentioned on the previous page by including options involving weight, baseline behavior (straight, tilted, or curved), letter sizing, gesture (roman vs. italic or oblique), and the use of more than one font. All are worth deliberating for at least a moment or two as you decide on the best possible way of presenting the word you're featuring in a logo, headline, or page graphic.

Use mixes of typographic specifications to generate connotations of energy, change, modernity, quirkiness, and more. If conveyances like these seem like a good fit for your project, start penning some thumbnail sketches, and maybe do a few quick trial runs on the computer. It won't take long to figure out if you're onto something, or if you should return to more standard modes of typographic presentation.

fictionist

Standard ligature Discretionary ligatures

fictionist

Th ff ffb ffi ffj ffl fh fi fj fk fl
ft Th Th ſb ſh ſi ſk ſl ſſ ſſi ſſl
ſt γγ ffh ffk fft ct fb ft sp st

Font ligatures

Custom ligatures

Unsightly things can happen when certain letters appear sequentially within a word. For example, the terminal of a lowercase f can collide—or nearly collide—with the title of a lowercase i when the former precedes the latter. When this occurs, and when a font has been programmed to automatically handle situations like these, a specially designed glyph that features a graceful connection between the two letters is inserted in place of the two individual characters. Glyphs like these are called *standard ligatures*, and, as long as a typeface contains them, programs like InDesign and Illustrator usually put them in place automatically.

Some fonts, like Adobe Garamond Pro (used for the samples above), also include *discretionary ligatures*. These ligatures are designed to add notes of style to a word, and their use is optional. Fonts that include discretionary ligatures offer them through the Glyphs panel in Illustrator and InDesign. You can take a full look at all the glyphs offered through a particular font (if it has any) by opening this panel.

And then there are the kinds of ligatures that need to be custom-created. Could a treatment of this sort improve the visual and conceptual impact of something you're working on?

Primary areas of concern

FLASHPOINT

Type taken directly from the computer

FLASHPOINT

Better letterspacing

FLASHPOINT

Tightened letterspacing with letters allowed to touch

L FLASHPOINT T

Letterspacing further refined by narrowing certain letters

Letterspacing strategies

In music, wrong notes bring jarring interruptions to the ears of listeners, disrupting their enjoyment and perception of a song's melody and message. Poor letterspacing does a similar thing to viewers by sending tiny—and sometimes large—impulses of discomfort and/or confusion through their eyes and into their brains.

Artistic unpleasantries like these need not be clearly noticed—nor do their causes need to be fully understood—in order for them to perturb and annoy through the channels of human perception. Therefore, it's important that artists of any medium take care to avoid gaffes that will negatively affect their audiences' experiences—designers who work with type included.

What makes letterspacing good or bad? Consistency, or a lack thereof. Good letterspacing (or kerning) appears uniform throughout a word, and therefore keeps the eye from being drawn to areas that are either too loosely, or too tightly, spaced. Good letterspacing also keeps the brain from wondering about the craftsmanship that went into a word's presentation. At its worst, poor letterspacing can even make the viewer wonder about what they're reading—as when an overly large gap between letters makes it appear as though a new word has begun.

Letterspacing is a vital subcomponent of any designer's job: Take a good look at the tips featured opposite if you have any doubts about your letterspacing capabilities.

Quality typefaces offer good letterspacing by default. But even good letterspacing doesn't always work out great—especially when certain sets of letters are used at larger sizes (as is usually the case with logos and headlines). And this is where the designer needs to intervene and fix things up.

How can you evaluate the letterspacing of the words you're using? Here are some tips. First of all, know that letterspacing is not an issue of mathematics: It's a matter of instinctual aesthetic judgment. Look at the spacing between each of your word's pairs of letters and ask yourself, *Do these spaces appear consistent throughout, or do certain letters need to be shifted left or right?* Look at each trio of letters within your word, too. Aim for absolute kerning consistency between each of these sets of characters: None should appear tighter or looser than any of the others. Try squinting your eyes tightly as you evaluate a word's letterspacing. Squinting can bring to your attention darker or lighter masses among the word's characters— indicating pairs or groups that are either too tightly or too loosely kerned. Print your word backwards and at a large size on a sheet of paper, stick it up on a wall, step back, and evaluate from there. Assessing a word in this way will give your eyes a completely fresh way of seeing how its letters are spaced.

Learn to see the negative spaces between, and inside, letterforms when evaluating letterspacing in the ways talked about above. After all, letter*spacing* is about the *spaces* within a word as much as it is about the letters that make up the word.

Good letterspacing allows a word to speak for itself through both its literal meaning and the conveyances of its aesthetics and style—and without the distractions that occur when certain characters are either clumped or too far apart.

Look at the different pairs of letters in your word. Does their spacing appear consistent?

DIADEM

Inspect trios of letters as well. Does each triplet come across as being spaced the same as each of the others?

89

DIADEM

DIADEM

PRESENTING WORDS

As most of us have learned—both by having it told to us and by experiencing it firsthand—it's not so much a matter of what we say as how we say it.

This adage holds for words we set in type, too. In fact, it may be even more of a truism when it comes to words that communicate visually—as opposed to those that are delivered verbally—since typeset words offer themselves to viewers without the additional meaning-enhancing cues given through tone of voice, facial expressions, and body language.

As mentioned on page 48, typefaces carry their own projections of voice and personality, and it's essential to keep this in mind when choosing fonts. What criteria should you be aiming for when determining whether or not a typeface's expressive qualities are suited for the layout you're working on? The answer, in the case of design projects aimed at a particular audience of viewers (as nearly all design projects are), is this: Your chosen typeface—whether it's an existing font or something you modify or create from scratch—should aesthetically and thematically convey itself in a way that connects with the tastes of your target audience, while also bolstering the layout's verbatim and conceptual messages.

Spend the time and effort necessary to figure out just who it is you'll be trying to reach with the typographic elements of your piece before going too far with its development. This may mean doing some research about the people you're targeting with your design; it might mean talking to your client about their hopes and expectations in regards to reaching their customers or clientele; and it might mean spending time looking at the media your target audience favors in search of clues (often a very helpful thing to do). And while this advice may seem somewhat disconnected to the subject of typography, it's advice that applies in nearly absolute terms to virtually all works of commercial design—the vast majority of which depend heavily on typefaces to deliver their message.

Elucidate
Elucidate

Elucidate

Elucidate

Elucidate

ELUCIDATE

Elucidata

ELUCIDATE

elucidate

Word legibility

Traditional serif fonts are generally considered ideal for large and small blocks of text. The thick and thin strokes of a serif font lend a pleasing look of subtle diversity to areas of text, and the horizontal serifs of most roman fonts assist the eyes of viewers by helping to guide their gaze along lines of words.

A cleanly designed sans serif font can also work suitably for text. To most viewers, text set in a sans serif font will come across as more functional and less literary than text set in a classic serif font. With this in mind, be careful not to use a sans serif font for text that would be better shown in a serif face, or vice versa.

Display faces are risky choices when it comes to presenting text. Most display and novelty faces are designed to be used for large, standalone typographic elements such as headlines and logos. Every so often, however, a designer will find and opportunity to use a display font for text—as when aiming for intentional conveyances of humor, quirkiness or kitsch.

Text legibility

Legibility is in the eye of the beholder, and different beholders have different opinions about what kinds of lettering can be easily read. Still, one thing is certain: Every logo and layout you produce needs to be created with legibility as a priority—legibility as determined by the tastes of your target audience.

Classic serif and sans serif fonts are usually a safe bet when it comes to readability. Same for monotype fonts. As for black-letter, display, novelty, and some script fonts, that's where your designer's instinct and judgment come into the picture—as well as your knowledge of the likes and dislikes of the people who will be looking at your work—as you decide whether or not the fonts you're using are appropriately legible.

Readability is one thing when typefaces are used at large sizes—as in the case of headlines and most logos—and quite another thing when it comes to blocks of text.

Text is generally best served by clean-looking serif or sans serif typefaces (more on this on page 185). Display and novelty fonts, on the other hand, are generally out of the question when it comes to text because of their inherent illegibility when presented en masse at smaller sizes.

94

REVERSAL

PIXELATE

COLANDER

CHAPT3R

Simple word treatments

When a project involves looking for ways of altering letters for the purposes of attracting, amusing, intriguing, and/or informing viewers, this is where design can become especially interesting and enjoyable for both experienced and newer professionals.

Letter alterations need not be glaringly obvious in order to convey an idea or a theme.

Sometimes subtle is best.

Of the four examples presented on this page, three involve visual treatments applied to only one letter. This sample features a meaning-echoing effect that's been used on each of the word's characters. Consider both approaches—and all strategies in between—whenever brainstorming word-altering ideas.

Are numerals in any way involved in the logo, headline, or word graphic you're working on? If so, is there an intriguing and eye-catching way of combining your number and letters?

And what about color? Could a splash of color be used to direct attention to whatever alterations you've made to a word?

Sinking

effervesce

VENETIAN

snwflake

Here's a modification that adds a note of *happening* to a word. Consider visual approaches along these lines when working with words that deliver implications of motion, changing, doing, or being.

Sometimes a deftly handled change of font can infuse a word with just the touch of elegance, formality, rebelliousness, or dismay you're looking for.

Consider effects like gradients, transparency treatments, special applications of color, and the utilization of appearance-altering effects (like those offered through Photoshop's Filters menu) when searching for ways of presenting words.

Replacing letters with images is a visual tactic well worth considering whenever you're looking for ways of echoing or enhancing a word's meaning.

(Note that a discretionary ligature has been used between this word's f and l to improve its letterspacing—see pages 37 and 87 for more about ligatures.)

SEQUENTIAL

EPHEMERAL

Simple word treatments (continued)

Certain letters feature elements that can be replaced with shapes or imagery without a serious affect on legibility. Treatments like these can be understated or obvious.

It's fascinating how the eye and brain can work together to read words that contain few, if any, actual letters.

What about employing non-traditional ligatures between your word's letters to deliver thematic expressions like connectivity and flow?

This word was imported into Photoshop where an image of crackled paint was superimposed over top, and a Blur filter was applied to its lower half. Illustrator is the usual working environment for most designers who are dealing with appearance-altering changes to words, but there are some treatments that Photoshop can handle with greater flexibility and ease.

RAINBOW
RAINBOW
RAINBOW
RAINBOW

Using interiors

Pages 70–71 show examples of imagery inserted into the interior spaces of individual letters.

Keep in mind, too, that with words, not only can the insides of letters be filled with colors, patterns, decor, illustrations, and photographic images, but the spaces *between* letters can be as well.

MANIFEST

MANIFEST

MANIFEST

MANIFEST

Dimension

Dimensional effects are another realm worth exploring for certain design projects involving words. But at the same time, be a bit wary of dimension-implying treatments as they are susceptible to the same whims of fad, fashion, and favoritism that affect all visual contrivances; looks that are highly popular one year might be the bane of public opinion the next (at least in the minds of people who are highly aware of such things— as a surprising number of people seem to be).

Each of the samples shown above were created in either Illustrator, InDesign, or Photoshop.

EFFECT > STYLIZE > DROP SHADOW

Looking for a particular effect for the logo, headline, or word graphic you're working on? Take a look at these thirteen effects that were achieved in Photoshop.

Let these samples point you toward solutions, using them as starting points as you work with your computer to produce exactly the look you're after for your project.

Also, be open to surprises that occur when you apply different settings within certain filters and effects (all of the treatments displayed here offer control panels that allow you to fine-tune their effects). Even if the results you come up with aren't immediately usable, some may be worth a mental bookmark for potential use in the future.

EFFECT > DISTORT & TRANSFORM >
ROUGHEN

EFFECT > DISTORT & TRANSFORM >
ZIG ZAG

EFFECT > WARP > SQUEEZE

EFFECT > WARP > ARC +
EFFECT > STYLIZE > DROP SHADOW

EFFECT > SVG FILTERS >
AI_PIXELPLAY_1

EFFECT > 3D >
EXTRUDE & BEVEL

EFFECT > 3D >
EXTRUDE & BEVEL

EFFECT > TEXTURE > TEXTURIZER

99

EFFECT > DISTORT & TRANSFORM >
TWEAK

EFFECT > STYLIZE > SCRIBBLE

EFFECT > SVG FILTERS > ALPHA 4

EFFECT > BLUR > RADIAL BLUR

Try out these four word-based typographic exercises. Each are connected to the kinds of real-world projects that designers regularly encounter when working on logos, headline treatments, page graphics, and more.

Voicing through fonts

Your job here is straightforward, and not only will it help you get acquainted with the typefaces on your system, it will also give you the chance to evaluate and choose between their many differing personalities. For this exercise, we'll use the word *Opulence*. Open a program like Illustrator or InDesign, go through your type menu, and look for fonts that connect with the word's definition in the following five ways: strongly, subtly, neutrally, contradictorily, and with a feeling of humor, quirkiness, or kitschiness. You can set the word in caps, in lowercase, or with an initial cap. When you're done, stack your five words in similar sizes on a vertical letter-sized document. And last, fine-tune each words' letterspacing prior to final evaluation.

Minimalist exercise

This project can be done in either Illustrator or InDesign. Typeset any two of the words listed below in a typeface of your choice and in whatever case you like. Use digital tools to remove as much as possible from each letter of your two words while maintaining their overall legibility. The sample at right is an example of this kind of presentation, but you may choose to accomplish this exercise's minimalist goals in whatever way you think is best. Choose your two words from this list:

Disappearance

Barely

Ambiguity

Anemia

Dematerialize

Illusory

Figment

100

Digital exploration

Free ranging creative exploration is a great way to learn about the capabilities of digital media. And whether or not you've had the chance to learn about the tools and treatments offered through Illustrator and Photoshop (through either play or work), here's your chance to deepen your understanding and broaden your experience with these programs. The instructions are simple: Apply filters and/or effects to the four words listed below in ways that emphasize each of the words' meanings. Feel free to apply more than one digital treatment to each word, but avoid overusing any particular filter or effect, and also avoid allowing any of your finalized words to look too similar to any of the others. Font choice is entirely up to you. Here are your four words:

Acousticophobia (fear of noise)

Amychophobia (fear of scratches or being scratched)

Apeirophobia (fear of infinity)

Atomosophobia (fear of atomic bombs)

The power of one

Elastic. This is the word you'll be using for this exercise. Your task is to modify one, and only one, letter of this word in order to convey its meaning. Set the word the lightest weight of Helvetica you have on your computer (use a substitute sans serif font if you don't have Helvetica); present the word in whatever case you like; feature the word large enough to nearly fill a landscape-oriented letter-size document; take care to fine-tune the word's letterspacing as necessary; and know that the modifications you make to your chosen letter can be of any sort and may be handled using whatever software you like.

ADDING DECOR AND IMAGERY

It doesn't take much to transform a word that's been set in a standard font into a uniquely special, one-of-a-kind typographic creation imbued with beneficial connotations of feeling and meaning. An expressive ornamental element, for example, could be placed near—or attached to—one of the word's letters, a tastefully curving extension might be added to one or more of its characters, or a theme-enhancing pattern or image could be employed as a backdrop or an enclosure around the entire word.

102

Type-plus-imagery can be a particularly challenging, enjoyable, and rewarding realm of visual and thematic exploration for graphic designers. The possibilities are staggeringly vast, and very often, the best ideas hide themselves until after a fair amount of brainstorming, thumbnail sketching, and on-screen exploration have taken place. Two pieces of advice. First of all, don't panic if you're in the midst of looking for solutions and don't feel like you're getting anywhere. As many an experienced designer could tell you, those professionals who are best known for the quality and diversity of their work are very often the very same ones who are known for the patience and tenacity they exhibit during the idea-development phase of their projects.

And the second piece of advice is simply this: Starting now, and for the rest of your creative career, place *creative blocks* in the same category as winged unicorns and giants who live at the top of beanstalks—each being the stuff of fable and fiction and nothing that could possibly interfere with your artistic output.

REVERIE

REVERIE

REVERIE

Simple extensions and replacements

Extending components of letters into swashing, swirling, and bordering forms—or removing bits from certain letters and replacing them with flowing alternative elements—can be very effective ways of turning a typeset word into an attractive custom logotype or word graphic.

Modifications like these can be performed relatively easily and quickly if you know even the basic workings of a program like Illustrator. The possibilities presented through these kinds of treatments are extensive, and any letter of the alphabet can provide at least a few look-enhancing opportunities involving either letterform extensions or component replacements.

That said, there are certain characters that seem more open to these kinds of modifications than others. The legs of the letters R and K, for example, and the tail of the Q, provide excellent opportunities for curving and swashing extensions; A, E, F, and H feature a crossbar and/or a stroke that can be removed and replaced with decorative or geometric alternatives; A, M, N, V, W, and X each include angled strokes that can be extended above and/or below their natural forms as graceful swashes, as can the ascenders and descenders of the lowercase characters like b, d, h, k, l, p, q, and y.

104

Backdrops

Enclosures

How about adding a backdrop to the word you're working with? The backdrop might be ornately drawn (or scanned from a copyright-free source, as in the case of the uppermost sample in this column). The backdrop could be a simple shape, and it could be given a color that contrasts nicely with the hue of the type it holds. And what about creating a contemporary backdrop from a grid of basic geometric forms?

Backdrops can be employed to establish a protective visual barrier around the word(s) they contain; add thematic notes missing from the type they hold; amplify the conceptual feel arising from their type; or contradict their type's thematic tone (more on this at far right).

Among many other possibilities, enclosures can be designed to embrace typographic elements from above and below (or from either side, for that matter); they can be employed to do exactly what their name implies: enclose, fully; and they can be designed as decorative extensions that flow naturally from one or more of the letters they surround. (More about enclosures and typographic assemblages can be found on pages 116 and 177–179).

REVERIE

REVERIE

Reverie

REVERIE

reverie

Ornamental add-ons

Each of the samples above are made from standard type-faces that have been adorned with simple visual ornaments borrowed from typographic families of decorative designs.

In the end, you might decide to go with a more complex solution than those seen here for the type-plus-image creation you're working on (solutions like those seen on pages 110–115, for example), but always keep in mind that the shortest route to effective design is sometimes the best route of all (which isn't to say that straightforward design entities of this kind are necessarily produced with minimal brainstorming—only that they may take a lot less time to produce than more intricate and involved word-plus-image visuals).

Correlation

These two examples contrast with the others on this spread in a significant—though subtle—way. Know what it is?

Here, the typographically rendered words and their accompanying imagery differ notably in theme: Crisp is combined with crude, and urban is paired with ornate. The rest of the spread's samples feature imagery and type that thematically agree with each other.

Remember: Thematic harmony is fine and good, but so is thematic dissent. What's right for any given project is for you to decide based on the kinds of expressions you're hoping to generate.

reverie

REVERIE

Dominant backdrops

Looking to fill a large area of
a layout with a minimal amount
of type? How about allowing a
theme-setting background image
or pattern dominate the space,
and letting the type play a sub-
ordinate compositional role?

STORY TROPHY SCRIPT ENCLOSURE
LEGACY TIMELINE EURO SANS CIRCULAR
SOPHISTICATION WREATH INLINE FACE SQUARE
SIMPLICITY LAURELS HANDTOOLED ELLIPTICAL
SOLIDITY HANDS CHISLED TYPE TRIANG
CLARITY COLUMNS TYPE ALONE? PATT
STRENGTH KEYSTONE W/IMAGE?
MODERN SCROLL
SILHOUETTE LIGATURE?
COAT of ARMS HAND-LETTER
WAX SEAL
SCEPTER

Every once in a long while, a designer is able to think of a great typographic solution for a client's project in an instantaneous flash of creative enlightenment.

Much more often, however, the process of brainstorming and developing typographic creations is considerably more involved, and is worthy of whatever time and effort you can put into it. After all, no matter how expertly a logo, headline, or layout is finalized, it doesn't stand a chance of reaching the realm of excellence if it's based on an underdeveloped message, a poorly communicated theme, or an off-base stylistic appeal.

Try the routine outlined on this spread as the basis for your conceptual exploration and design development the next time you're working on a typographic project for a client. It's a routine that's aimed at getting a project off to a well-targeted beginning, and leading it smoothly all the way to presentation-ready designs.

Begin, of course, by talking to your client, and taking notes on what they're hoping to achieve through your design. Query them thoroughly, too, on the tastes of their target audience (you may also need to spend time on your own looking into these preferences).

Resist the temptation to turn on the computer once you're back in your office or studio. Instead, launch into your creative work by opening up a sketch pad or a notebook. Do yourself a great favor by making lists of words that can be used to supercharge the brainstorming process you're about to begin.

One of your lists should include your thematic and aesthetic goals (refer to this list throughout your project to make sure you're staying true to the objectives set forth by your client and yourself). Other lists should serve as idea fuel: nouns that describe visual or decorative material that might be added to your type, adjectives that describe qualities your creation could (or should) convey, and pretty much anything else you feel like jotting down in relation to the work ahead.

Spend some serious time and energy on this list-making stage of your project. It may not feel like *design* or *art* at the time, but it's likely that you'll thank yourself later for the words you've written down—once they begin to act as powerful idea-starters in your head.

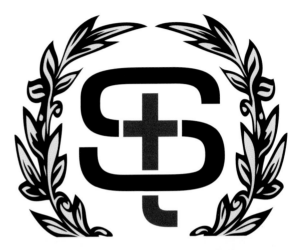

Next, simply look at the words in your lists and see what ideas come to mind. Look at individual words, and also—very importantly—look at pairs and sets of randomly associated words from your columns (surprisingly often, it's unexpected associations among randomly chosen words that bring up the most intriguing conceptual and visual ideas).

The step that naturally follows, as ideas begin to take shape in your head, is to somehow record and save your ideas. And for most designers, the best way of doing this is by making quickly rendered *thumbnail sketches* (a.k.a. *thumbnails*). Thumbnail sketches don't need to be neat or overly detailed. They simply need to serve as reminders of ideas that may be worth developing (and possibly finalizing) later on.

Large sheets of paper, by the way, are best for thumbnail sketches: Big paper tends to invite big ideas, and more of them, whereas small sheets can bring forth undesirable sensations of creative restriction and confinement.

Spend as much time as possible with your word lists and sketches. Circle potentially great ideas as you go, and work until you have at least enough strongly circled material to develop into an appropriate number of designs for presentation.

Now, at last, it's time to turn on the computer. Perhaps you will be scanning some or all of your thumbnail sketches for use as guides as you develop your designs, or maybe you'll simply be eyeballing your sketches as you work on the computer. Either way, the time has come to launch software and produce presentation-ready works of design.

Be sure to explore font choices as you develop your ideas (see page 148), and also try out different approaches as you consider the exact ways in which illustrative or decorative elements (if any) will associate with your piece's typography. Color choices may enter the creative equation at some point of this process, too.

And don't forget to cross-reference those client-based and target-audience-directed goals you identified at the start of the project: Make sure you're still on track with these objectives right up to the finish.

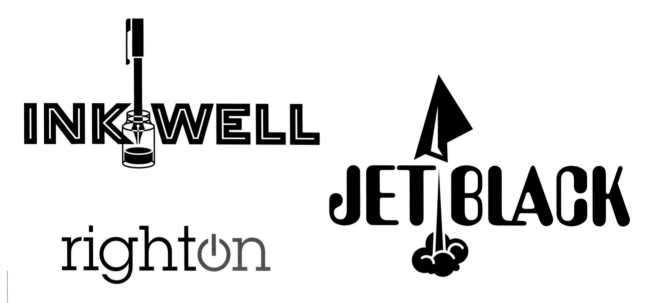

Adding imagery

Attractive and appealing word/image combinations for logos and word graphics can be created in endless ways. This is good news for designers since it means all you really have to do is find one—or maybe three or four at the most—solutions from an infinite realm of possibilities.*

Make your search for potential word/image solutions easier by boiling them down to just these five essential qualities your creation needs to have: just the right font typeset in the perfect way; well-chosen representational or abstract subject-matter for your illustrative or photographic imagery; a visually and thematically effective style of presentation for your imagery;

an aesthetically and conceptually pleasing sense of inter-action between your type and imagery; and a compositional arrangement that results in good looking position and size relationships between your composition's elements. Also consider additional aspects of presentation involving the use of color and/or post-production effects.

*Author's note: A thank you, here, to my former design school classmate, Chuck C., for pointing this out to me in class one afternoon, many years ago.

CONSERVAORIUM

Here are a few tips to help you develop ideas for your word-plus-image creations. Brainstorm, of course (no need to cover that here since it was addressed on the previous spread). Write out your word in lowercase, all caps, and with an initial cap, using a pen, on paper, and keep these hand-drawn words in front of you as you ponder ideas mentally, through sketches, and on-screen (being able to glance at these different ways of exhibiting your letters might be just what's needed to help you figure out how to adapt a certain image to a particular typographic presentation of your word). Avoid the temptation to think of good ideas as being *good* too soon during the creative process—think of them instead as ideas that *might* end up being good as long as they aren't eclipsed by even better ideas that come up as you explore variations of each of your ideas (looking at variations of potential solutions is something you should always do when time permits). As touched upon on the previous page, always consider alternate font choices for your creation as you develop your idea—it's so easy to do when using the computer that there's really no excuse to lock yourself into a font choice until you're absolutely certain it's the right one. And finally, look to outside sources for additional ideas and inspiration (more on that on the next page).

112

ALABASTER

Ideas from others

Eleven examples of word-plus-imagery designs are featured
on this page and the two previous. Look at these samples,
stare at them, even, the next time you're in search of concep-
tual and aesthetic directions to pursue for a project of your own.
Look at other books, too, and at magazines and websites, that
feature strong examples of type-based designs.

Really try to understand the thinking that went into the exam-
ples you find. Doing so will very often launch idea-based chain
reactions in your own head that will lead you to solutions that
are uniquely your own.

SKYSCRAPER

SKYSCRAPER

SKYSCR█PER

Boiling it down

Five must-have qualities of word-plus-image creations were mentioned at the beginning of the previous spread, with the fifth being that you find aesthetically pleasing positioning and size relationships between your image and word. Your quest to find these effective aesthetic connections might be simplified and streamlined if you keep in mind that—fundamentally speaking—there are just three ways an image and a word can interact: An image can be placed in near-proximity to a word (along-side, below, or above); an image can be placed behind or in front of a word; and an image can be placed within a word (among letters or in place of one or more characters).

CLOCK

EB**O**NY

P**O**INT

CL**O**WN

SH**OO**T

WR**O**TE

The advantageous O

Got a lowercase or capital O in the word you're working with?
Be glad. At least one O means you have at least one area of
exploration in front of you with some real creative potential. The
letter O (and its structural relative, Q) can be filled with imagery,
patterns, decorations, and color; it can be used to frame
illustrations or photographs; and it can itself be transformed
into an illustrative rendering that may or may not retain its
characteristic roundness.

Of course, none of this is to say that the letter O must be used
in a special way when a word contains one or more. Just that
it's definitely worth thinking about.

114

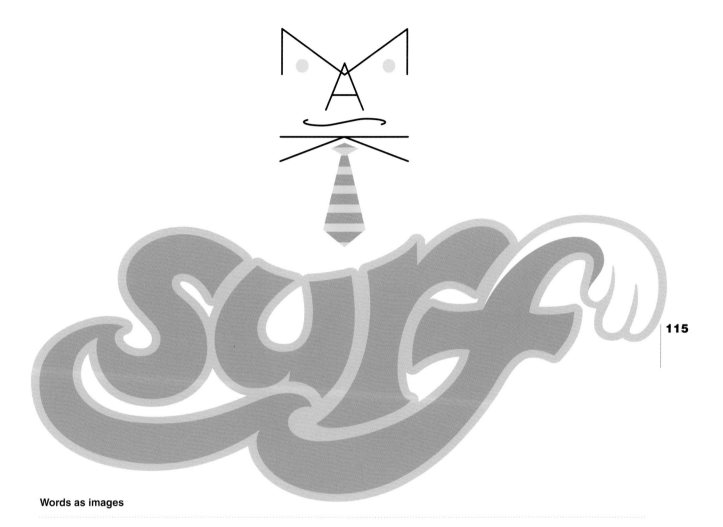

Words as images

Every once in a while, a project might come up that calls for the creation of a word that looks like—or depicts certain aspects of—a person, place, thing, animal, or symbol. Projects like these can be challenging, but mostly in good ways since they allow designers to flex all kinds of creative muscles: those that are connected with typographic know-how, illustrative skills, resourceful instincts, and communicative playfulness.

You can make word/image hybrids using letters from your font menu, by modifying existing characters, or by creating letterforms and image-based elements from scratch. Whatever the case, the results can be aimed toward all kinds of stylistic, aesthetic, and conceptual objectives.

Most any typographic project can benefit from a few thumbnail sketches that are done to get ideas flowing and forming. This is particularly true in the case of word-as-image creations. In fact, there's no better way of hatching opportunistic and quirky designs like these than by sitting down with pen and paper and doing some plain old freestyle sketching and doodling. Try using tracing paper, too, as you develop your ideas. You might be surprised how quickly you'll be able to refine even the roughest renderings if you're continually able to trace over them with improved drawings—the final of which you can scan and import into Illustrator for use as a guide to your finished art.

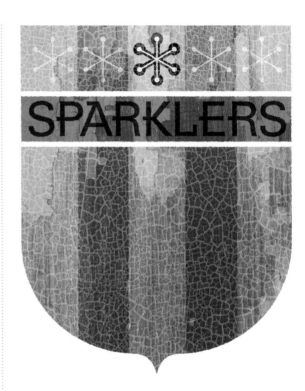

116

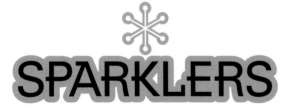

Wrapping tightly

Enclosure as starring element

Say you've developed the basic form of a type-based logo that features an icon as an accent element. Maybe the design is ready to go, just as it is. Or, maybe, it could use a touch more aesthetic energy and interest, and perhaps that energy and interest could be through a tight-fitting visual enclosure of some kind. The enclosure could be a simple shape; it could take on a form that influences the look of the type it holds (as in the case of the inward bowing design in the middle, above); it could be devised as form-following outlines that encase the type and the icon separately; or it could be designed in about a million other ways (several more of which are hinted at on pages 177–179).

And what about allowing an enclosure to dominate your design—at least in terms of the real estate it's allowed to occupy? The two designs, above and at right, devote generous amounts of space to non-typographic elements, while still presenting their all-important words and icons in eye-catching ways.

Would a solution built around an expressive, attractive, and oversized enclosure suit a project on your to-do list? If not, keep your creative radar open for future opportunities.

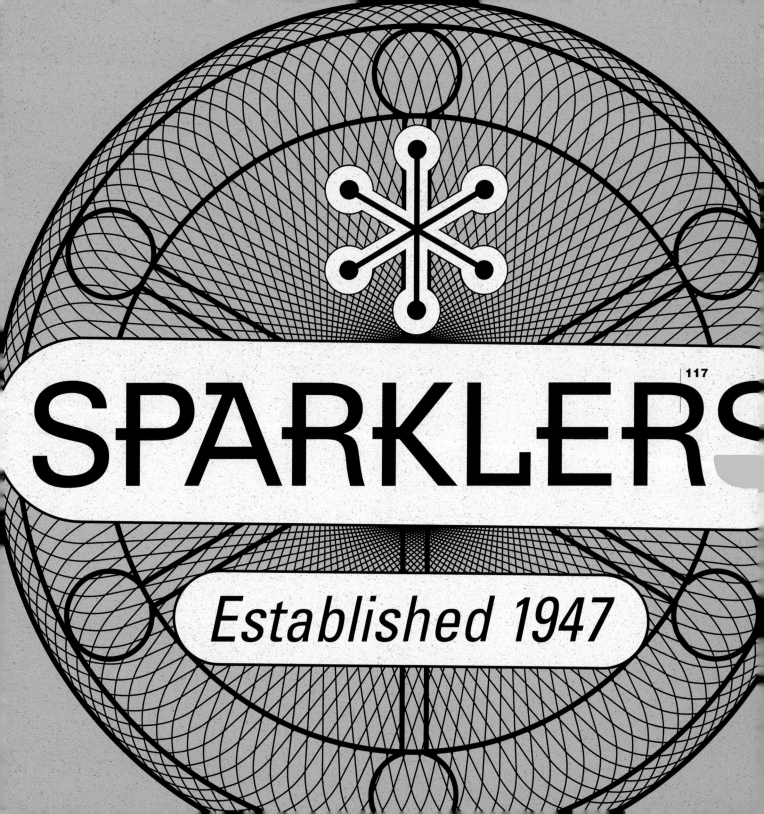

SPARKLERS

Established 1947

Adding, replacing, and modifying

For this exercise you'll create three different word graphics using this phrase: *Highs and Lows.* Each of your designs should hint at some aspect of the words' meanings.

With the first of your designs, make simple and subtle additions or alterations to one of more letters of your design. The second graphic you create should feature one or more letters that have been replaced with some kind of imagery—illustrated or photographed. And with the third, make major modifications to one or more characters—while still retaining hints of the original letter(s).

Guidelines: Keep legibility a primary concern as you work; apply a different typeface to all three word graphics; use any case configuration for each design; feel free to use an ampersand in place of the word *and;* consider setting your words in one line or breaking them into two or more; and incorporate color if you like.

118

righton

CONSERVATORIUM

CLOWN

Words, interrupted

Digital Comet. This is the word pair you'll be using here. Set the two words along a shared baseline using any font and case configuration you like. Then, come up with two or three ways of placing an illustrated image of some kind between the two words. Your added image should thematically connect with the meaning of the words, and it can be abstract, representational, or anything in between.

Treat each of your designs as though they were to be used as logos, and apply color if you want.

Word as imagery

Create a word-as-image design that depicts one of the following words: *Sun, cloud, wind, rain,* or *snow.* You can use the letters of an existing font for your creation or you can build the entire design from scratch. Totally up to you.

119

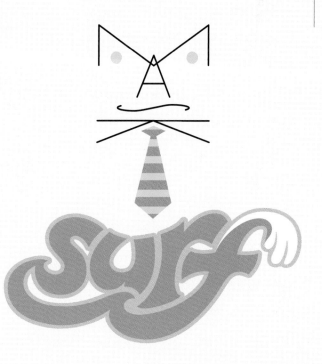

MAKING FONTS

Working on a logo, headline, or word graphic? Want to use a typeface that doesn't look like something straight from the font menu—but don't want to create your letters from scratch? How about coming up with something original by making modifications to an existing face?

Your modifications could be simple and quick, as when the edges of a typeface's letters are roughened with a digital effect, or when its letters are proportionally stretched using software treatments.

You could also make more involved changes to a stock typeface. You could modify its strokes to include angular, curved, or spiked endings; remove or redraw some of its characters' components for stylistic effect; and/or deform (warp, bend, twist, and the like using digital effects) its letters to the point where there's little left of their original look.

You might want to begin work like this with a set of idea-generating thumbnail sketches, and then search for a typeface that will lend itself well to the ideas you've come up with.

Or, you could jump right onto the computer and wing it. Just plug in a few fonts and start cutting, carving, adding to, and/or taking away from one or more characters until you establish a look that could be applied to each of the letters you'll be dealing with.

As with most any creative exploratory work, be willing to investigate solutions that seem to go both a little far and not quite far enough. It's the only surefire way of making sure your work is truly sitting in the sweetspot of visual and thematic perfection.

Industria

Bodoni

Edwardian Script

Space Age

DIN Next Slab

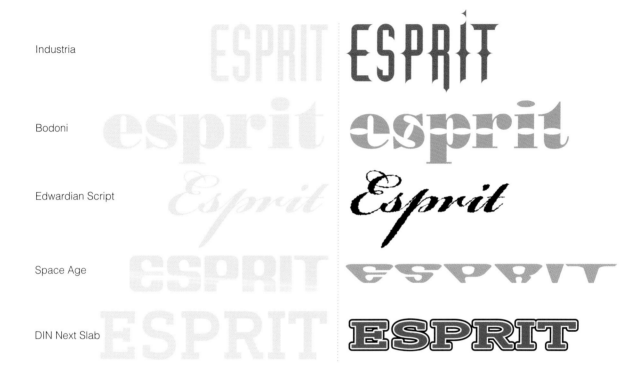

Modifying existing fonts

The words seen above at right are the result of form- and style-altering treatments that changed the look of the letters borrowed from the five typefaces at left.

Illustrator provides an ideal set of tools and effects for most letter-altering projects. Begin by choosing a font and a case configuration for your word(s), convert your characters to paths, and then look into different ways of altering their appearance. Keep copies of your original and/or partially modified word(s) somewhere in your document's workspace. That way you can return to them if you want to start over with certain modifications or if you want to come up with several possible solutions before picking a favorite.

UNIQUITY

UNIQUITY

UNIQUITY

Uniquity

Custom-built typefaces

Each of the custom-made characters in these words was inspired by the visual cues established for the sets of letters featured on pages 61 and 62. Anytime you're creating a font for a design project, keep in mind that you can speed up the process by beginning with only a few characters. An uppercase A, Q, and E and a lowercase d, i, o, m, a, g, and e, for example, can provide more than enough structural direction for an entire alphabet.

If you're working on a custom font for a logo, then you'll probably only need to finalize a small number of letters for your design. That said, if you have something going that you're especially fond of—or if your client wants you to go a step further with the typeface you're creating—you could go ahead and develop a full alphabet complete with numerals and punctuation marks.

From there, if you like, you could turn your typeface design into a fully functioning alphabet using font-editing software. FontLab Studio has long been considered the benchmark font-editing program but not all designers consider it the ideal choice for their work. Do some online research to find out what the current leaders are among font-editing programs and choose one that fits both your needs and your budget.

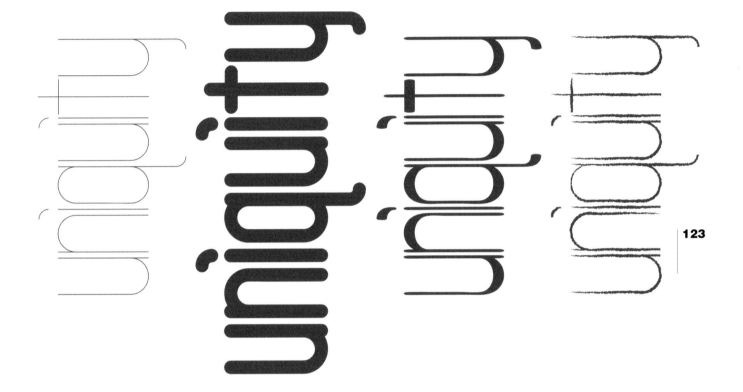

Linework options

Don't forget that if you use linework to create letters in Illustrator, you can ask the program to apply a wide range of styles to your strokes. This feature can be very helpful as you decide on the best look for your characters.

For example, once you've drawn your letters using lines, a few clicks of the mouse can let you see the letters as thin and uniform, bold with rounded stroke terminals, pseudo-calligraphically rendered with strokes of different weights, drawn as though with a pencil or a brush, and much more.

Whimsicality

Original

Whimsicality

Whimsicality

Whimsicality

Hand-lettering based on existing fonts

Looking for a more organic, casual, or whimsical way of placing words into a logo or on to a page? How about filling, tracing, or redrawing a typeface's letters by hand? It's a look that can suit some projects perfectly—particularly those that are meant to come across as grassroots or lo-tech.

Be resourceful and open-minded when rendering letters in these kinds of ways. Launch Illustrator or Photoshop, set your word(s) in your chosen typeface, and then fill, trace, or reinterpret the letters using pen, pencil, and/or brush tools on a layer above. Try out different tools, settings, and styles as

you work. Take advantage of the Undo command when things don't go quite right, and turn your underlying layer off from time to time to see how your hand-rendered letters are looking on their own. Digital tools make it easy to cover lots of possibilities in a short amount of time when aiming for results like these.

Also, consider doing a variation on this process by printing your typeset word(s) on a sheet of paper and working with actual pens, pencils, or brushes on a layer of tracing paper over top. Once you're done, you can scan or import your lettering into the computer.

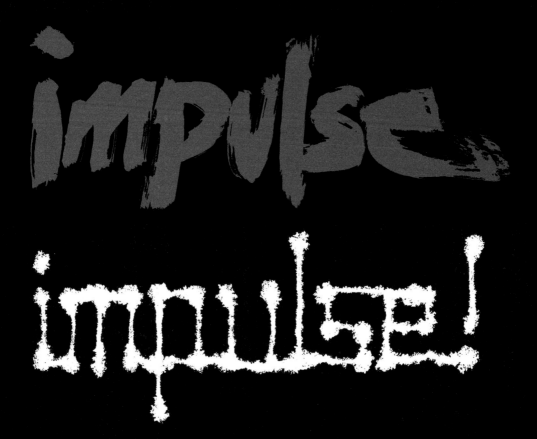

Lettering analog

Digital media can do a great job imitating real-life art tools, but few lettering artists would argue that working digitally is the same as using analog media like pens, pencils, brushes, ink, and paper. Analog tools can sometimes pull off finished results that are more intriguing and attractive than those done digitally. And sometimes it's the other way around. Try both approaches when lettering by hand before deciding which is the better fit for your project.

Both of the samples above were done using hands-on tools: The one at top was rendered with ink and a sumi brush (see the next spread for a step-by-step description of how this was done) and the lower piece was created with a rolling ball pen on absorbent tissue.

126

Not all of us have impeccable skills when it comes to lettering by hand. If this is you, then here's a method of creating hand-lettered words that allows for any number of mistakes and less-than-perfect renditions along the way to creating an attractive finished product.

First of all, decide which media you'd like to use: pen, brush, ink, paint, and so on. Also, if you have some samples of the kind of end results you're after, place them in front of you so you can refer to them once you begin lettering.

Next, prepare your paper by adding some light guidelines with a pencil and a ruler. Guidelines are important since they'll help keep your handwritten words the same size. This, in turn, will make it easier to cut good-looking letters from certain attempts and combine them with good-looking letters from others (as talked about ahead).

Now, go for it. Take a quick look at any samples you're trying to emulate, or use the mental image of what you hope to produce, get your tool of choice in hand, and then pen, paint, or ink your word on your sheet of paper. Next, do it again. And again and again. Write your word many times and, with every effort, strive for just the kind of lettering you're hoping for.

And here's the most important thing. Don't worry about it if not even one of your hand-lettered words looks perfect as a whole. That's not the goal here (though if it does happen, be happy). The real objective at this point is to write your word enough times that you end up producing individual letters or sets of letters that look great on their own. Given enough attempts, there's a very good chance that you can come up with just the parts and pieces of your word needed to create a composite that has the look you're after.

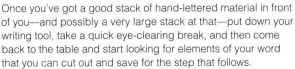

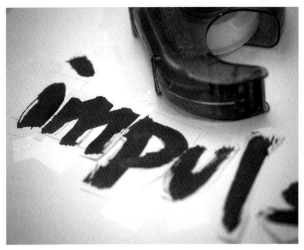

Once you've got a good stack of hand-lettered material in front of you—and possibly a very large stack at that—put down your writing tool, take a quick eye-clearing break, and then come back to the table and start looking for elements of your word that you can cut out and save for the step that follows.

Be sure to look carefully through each of your word-renderings for usable material. You might, for example, find whole letters or sets of letters that you think are perfect, or you might find small details like the dot of an i or an attractively inky edge of a stroke that could be added to any character that could use it. Cut these letters and details carefully from your assortment of words using scissors or a knife and set them aside. If you come across more than one likable version of a letter or a detail, cut and save all of them for possible use.

Finish by finding the best possible way of composing the letters and details of your word into a scanable composite. Assemble all your parts and pieces on a fresh sheet of paper and tape them into place (avoid placing tape directly over any letters since this might cause problems when you scan your artwork).

Step back from time to time and evaluate what you have going on. Try out different versions of certain letters—and pieces of letters—until you have just the arrangement you're looking for.

When you're happy with what you've got, erase any penciled guidelines among your letters, scan your composite word, bring it into Photoshop, and use digital tools to fill in any unwanted gaps between letters and to make any other changes you like—including the addition of color or the application of effects.

128

The illustrated word

How about it? What about merging the ideas of *type* and *illustration* for a masthead or a headline? The typography and illustrated components of this piece were created and colored in Illustrator, and were then imported into Photoshop where various visual textures and a rough-looking border were added.

Most designers would consider a project like this to be a good day on the job since it brings together so many things that drew them to design in the first place: typography, imagery, artistry, color, communication, and style.

Keep something like this in the back of your mind for future projects, and have some fun with it when you get the chance.

129

Reinterpreting by hand

This exercise connects with the hand-drawn interpret-ations of typefaces sampled on page 124. Here's what you do: Open Illustrator or Photoshop; set any word you like using whatever font you want; apply a very light color to your word (the word will only be used to guide your renderings in the steps ahead, and making it light will keep it from interfering with what you'll be doing); add a blank layer over the top of the word; use some kind of pencil, pen, or brush tool to retrace, outline, and/or fill in the letters' forms in a semi-loose and spontaneous way* (see page 124 for examples of the kinds of things you might aim for).

Have some fun with this project. Loosen up. Imagine that your finished piece will be used as a headline in a contemporary downtown-style tabloid.

*An alternative to this routine would be to replicate the steps outlined above using a printout of your word and then drawing, penning, or painting your interpretation of it on a fresh layer of tracing paper.

Altering existing typographic forms

Use a light, medium, heavy, condensed, extended, or regularly proportioned sans serif typeface to set these words in all caps: *STENCIL*, *SHARPEN*, and *SUBTRACT*. You may use the same font for all three words or use three different fonts. Next, bring your words into Illustrator and convert them to outlines. From there, make modifications to some or all of the characters of each word (alterations along the lines of—but not limited to—the look of the visuals on page 121). The alterations you apply to each word should transform its original font into something very different, and they should also present the word as a reflection of its meaning.

Put whatever Illustrator skills you have to good use, and try to expand your skills as needed to suit the kinds of modifications you're aiming for with this exercise. A tip: Illustrator's Pathfinder panel offers many operations that are ideally suited for a project like this.

Expanding on your custom-crafted letters

This exercise builds on work you may have done for the final project on page 67. (If you haven't already done that project, then you'll need to do it as the first phase of this one.)

Use the letters you created for the earlier exercise to guide your creation of enough characters to populate this word: *Honorificabilitudinitatibus*.* (This word has the distinction of being the longest of any in Shakespeare's writings, and also one that happens to be the longest in the English language that's made up entirely of alternating vowels and consonants.)

*Extra credit for this exercise may be earned by teaching yourself to actually pronounce this word, and possibly using it in a complete sentence the next time you're at some kind of social gathering.

Illustrated word

This one's more involved, but it's a very worthwhile project, and one that's well worth doing whether or not you consider yourself a skilled illustrator. Here's the exercise: Choose one of these three words (none of which can be found in the dictionary): *automobilia*, *organica*, or *urbanicity*; render the word as a from-scratch illustration (an example of which can be seen on pages 128–129); present the word in whatever case configuration and typeface-echoing style you like; use digital or hands-on media; and render the word in a way that conveys its implied meaning.

Worried that you may not have enough skill as an illustrator for this one? Don't be. Any and all designers (of any and all skill levels) can bring whatever abilities they have to the table here—whether that means using a collection of colored shapes to create letters, doodling with basic digital drawing tools, or even scribbling an interesting design with a box of crayons.

132 | CHAPTER 4

Multi-Word Presentations

LOGO, HEADLINE, AND WORD GRAPHIC FUNDAMENTALS

Typography as it applies to solitary letters and individual words was the focus of this book's earlier chapters.

Here, the topic is *words*. Plural—as in *words* that show up in logos or as headlines or word graphics within layouts. And more words means more opportunities for creative expression—which is always good news for designers, right?

Naturally, topics like typeface selection, the thematic effects of font choices, type-plus-images strategies, and legibility concerns will be talked about in the pages ahead—just as they were in earlier chapters.

New here will be discussions of baseline configurations (straight, slanted, curved,and so on) as they apply to both single and multiple lines of type, size relationships between words that appear together, and strategies involving using different fonts within multi-word designs.

And lastly, because this chapter often deals with assembling multiple typographic elements into cohesive designs (sometimes with imagery, too), it also gets into a discussion of visual hierarchy. Visual hierarchy is the apparent pecking order of a composition's elements, and it can be a real make-or-break factor when it comes to the aesthetic impact of logos and word graphics. (You'll also find visual hierarchy talked about quite a bit in this book's final chapter, Text and Layouts, beginning on page 182.)

134

Bluebird Hats

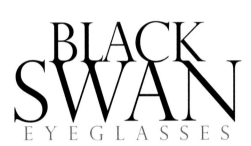

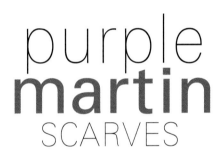

GOLDFINCH GOWNS

Simple and effective

Before getting into more involved type and type-plus-imagery solutions for logos, headlines, and word graphics, a reminder: Some of the most elegant and effective typographic solutions are also the simplest.

Each of the logos shown here are made from the characters of a single typeface, and each is presented without any kind of special effect, backdrop, or add-on imagery.

It's not only fine feathers that make fine birds

It's not only fine feathers that make fine birds

It's not only fine feathers that make fine birds

IT'S NOT ONLY FINE FEATHERS THAT MAKE FINE BIRDS

Font choices, font voices

136

Going along with the notion that the man named Aesop lived and wrote fables about 2000 years ago (an assumption that's been debated by historical scholars for many, many years), a quote from his fable *The Jay and the Peacock* is presented here through eight different typographic voices.

The two samples shown above are featured in fonts that might be seen as expected choices for time-tested words of conventional wisdom—in the minds of many viewers, anyway.

A casual brush-style font injects the type at top with notes of playfulness, good-natured wit, and kitschiness. This projection of personality is clearly different than that coming from any of the other quotations on this spread—a claim that could also be made by each of the other quotations individually.

The ultra-bold Helvetica used for the lower example delivers the quote's message with an emphatic feeling of absolutism.

Ponder for a moment how each of the quotes presented on these two pages might fit into a layout, what kind of imagery that layout might include, and what the piece's overall message might be. Quite a range of differences, aren't there?

It's not only
fine feathers
that make
fine birds

It's not only fine feathers
THAT MAKE
FINE BIRDS

IT'S NOT ONLY
FINE FEATHERS
THAT MAKE
FINE BIRDS

It's
not only
fine feathers
that make
fine birds

137

At top, two weights of the same contemporary serif font lend different levels of inflection to the quote's words—much like a speaker's voice might be used to affect certain aspects of a verbal message.

At bottom, two typefaces that clearly don't have any sensible business being seen together work as one to add inferences of a hidden meaning or an inside joke to this presentation.

If the highly unorthodox typeface featured at top were applied to this quote, and if the quote were part of a layout, then viewers might feel strongly compelled to read the layout's text in search of an explanation.

The lower font, being heavily biased toward an era of bygone grooviness, might be just the thing needed to convey these words if they happened to be paired with imagery and/or text that was similarly themed.

The lesson of all these samples? The moral of the story? *Take at least as much care choosing your fonts as you do your words.*

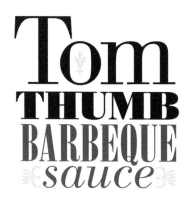

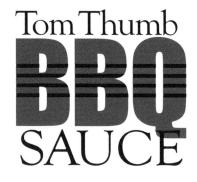

138

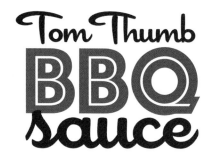

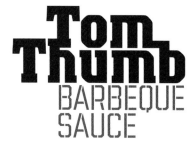

Combining fonts

You can find much advice about combining fonts: what works and what doesn't. Here's this book's straight-up recommendation on the matter: Decisively aim for either clear and obvious connections or clear and obvious differences when combining typefaces.

The example at the middle top is a demonstration of conspicuous visual harmony between fonts. Each word of this design (and the two dingbats as well) share a common ancestry as part of the extended Bodoni typeface family.

On the other hand, the lower three examples all depend on obvious differences for the successes of their font pairings.

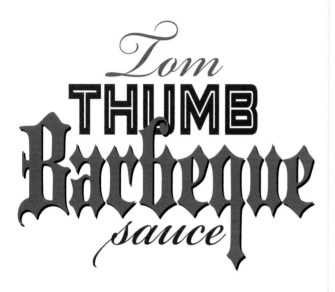

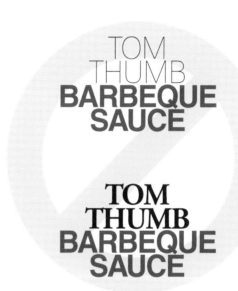

Multi-font failings

This sample, too, works well both visually and stylistically because of pronounced differences between the script, display, and blackletter fonts it uses. Marked differences in the sizes of the design's words also contribute to its expressive conveyances of diversity and energy.

Spend plenty of time on the computer trying out different combinations of fonts when working toward results like these. Experiment also with size relationships and color variables within your design. Give yourself plenty of possible solutions to choose from before deciding which ones are most worthy of further development.

The upper sample in this column pairs two sans serif faces: Futura Light and Helvetica Bold. Don't do this. As typefaces, Futura and Helvetica are not nearly different enough to be used together.

And the lower sample—even though it uses adequately different typefaces (Helvetica and Garamond)—presents its fonts in weights that are far too similar.

Fixes? Solutions? The upper sample could only be cured by going with a light/bold combination of fonts from just one typeface. The lower assemblage could be saved simply by applying notably different weights to the two fonts it features.

ALEXIS AVENUE
ARTISTS' COOPERATIVE

ALEXIS AVENUE **ARTISTS'** COOPERATIVE

ALEXIS AVENUE
ARTISTS' COOPERATIVE

Breaking lines

Some of the most important logo-building considerations are also the easiest to overlook. Line breaks, for example.

Line breaks are the points at which multiple words are broken down into more than one row of type. A logo doesn't necessarily need to have any line breaks (as demonstrated in the middle example above), but designers often apply breaks to help direct attention to a certain word or a group of words within a logo, and also to shape the footprint of a design into something other than a long horizontal rectangle.

Explore all kinds of ways of breaking lines when designing logos. Different sets of words provide unique compositional possibilities in this regard: Some line-break strategies may present positive design opportunities (like a functional overall footprint) while others might create insurmountable compositional challenges (like a line of type that is way longer than any of the others in a design, and for no good reason).

In addition to trying out different line breaks for type you're wanting to stack, investigate different weights and sizes for the words within your design. Weight and size attributes can also help put sought-after notes of emphasis where they belong.

ALEXIS AVENUE
ARTISTS'
COOPERATIVE

Nontraditional line breaks

Would the logo you're working on benefit from a footprint that's neither overly tall nor exceedingly wide, such as proportions that might lend themselves easily to a wide range of printed and posted applications? If so, try out line breaks, font weights, leading solutions, and justification settings* that help shape your design accordingly.

*The samples above make use of either justified or centered formatting, but flush-left, flush right, and even asymmetrical solutions could also be used toward similar ends.

Say you're working on a logo for a creatively aligned organization. An artists' cooperative, for example. Wouldn't it make sense—given the presumably open-minded nature of the organization's members—to explore unlikely and nontraditional solutions while you're at it?

What about offering at least one idea that dismisses some of the so-called *rules* of typography when presenting designs to the client? What about, for instance, applying non-traditional line breaks to the words you're working with, and using color-based cues to help viewers decipher what they're reading?

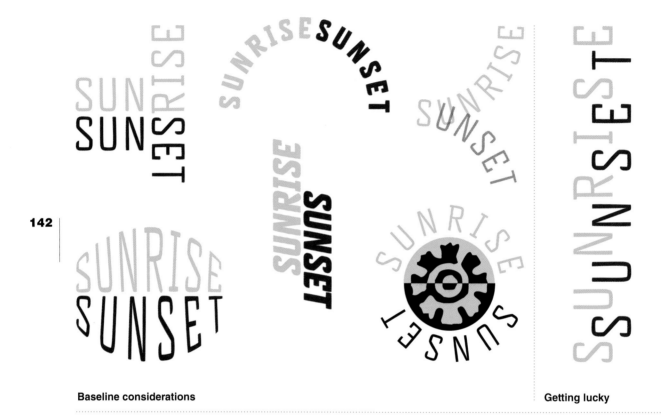

142

Baseline considerations

Getting lucky

Typographic baselines usually sit straight and level. But they don't have to—particularly when it comes to presenting words within logos and word graphics.

In addition to being horizontal, baselines (and ascender lines, too) can be vertical, slanted, curved, bent, or broken. They can also follow the form of a circle, a rectangle, a triangle, or an abstract shape.

Illustrator and InDesign offer several ways of altering the orientation, direction, and flow of baselines. Learn how to use these software features fluently so you'll be able to quickly and easily bring your ideas to life when aiming for out-of-the-ordinary baseline configurations.

Here's something worth keeping your eyes open for: situations where a word with a certain number of letters is being paired with a word that has either one more or one less letter. In these cases—and with the help of some wide-open letterspacing—you might allow baselines and ascender lines to overlap to produce an unorthodox and visually compelling arrangement of words.

This project is not unlike the kind of work you'd be doing if you were preparing to present a set of logo ideas to a client.

Type-only logo design

Here's the name of your client's business: *Zachary Avenue Cafe and Coffee House.* The establishment serves gourmet-quality lunches and the expected lineup of espresso drinks in a relaxed and contemporary atmosphere. Their target clientele is younger, well-to-do, urban professionals. Keep all of these factors in mind when designing.

For their logo, the client has specifically requested a design that's made purely from type—possibly with the addition of a backdrop panel or an enclosure of some kind. And, as far as the logo's type goes, font choices, case configurations, and the overall proportions of the design are all up for grabs.

The client has not decided whether they want to play up the restaurant's street name, the fact that it's a cafe, or that it's a coffee shop—or to emphasize all three of these things equally—within their logo. That said, make sure each of your ideas present different options in this regard (certain words in your designs could be emphasized through size differences, line breaks, the use of bold type, and/or accent colors*).

143

Your job is to come up with three ideas for presentation. Each idea should come across notably different than any of the others. This range of looks will give your client a good scope of approaches to consider. Keeping this in mind, it wouldn't be a bad idea to further expand the variety of your designs by presenting one in all caps, one as all lowercase, and one with an initial cap.

* See the following four pages for more about emphasis strategies such as these.

EMPHASIS STRATEGIES

The logo, headline, or word graphic you're working on may have several words, but are each of its words equally important to the reader? That's doubtful.

For example, let's say you're working on a logo for *Memphis Guitar and Music*. Within this name, does the word *and* deserve to be presented with equal importance as *Memphis*, *Guitar*, or *Music*? Probably not, even though it's a word that plays the important role of making sure people know that the shop has more than one thing to offer.

Which, then, among the words *Memphis*, *Guitar*, and *Music* is most critical? That all depends on which one—or ones—the client wants to emphasize. (Interested in seeing how different incarnations of this logo might appear, depending on different choices in emphasis? Turn to the next spread).

With considerations like this in mind, make it a priority to talk with your client about the relative significance of the words within the logo you're designing. If it turns out that one or more words needs to stand out above the others—as is very often the case—then make a point of coming up with a design that guides viewers to the word—or words—that need emphasizing. Take this work very seriously. After all, logos usually have only a second or two to catch viewers' attention, and if a logo's primary message can't be delivered within this amount of time, then it may not be delivered at all.

How can you establish different levels of emphasis among a logo's words? Two ways: First, by enhancing the visual impact of certain words by making them bigger, bolder, and/or more colorful than the others. And second, by making sure you're playing down the visual presence of other words within the design by restraining their size, weight, and coloring.

UNDER-STANDING VISUAL HIERARCHY

145

Directing the eye

The eye likes to avoid confusion by being given cues as to where it's supposed to look.

On this page, the eye is first drawn to a bold central word and its impossible-to-ignore colored character before being pulled toward typographic elements that offer themselves more quietly (this block of text among them).

Size considerations

Size differences, of course, are one way of ensuring that a logo's type sends the right message to viewers. And not only that, size differences between any of a composition's elements—especially when those differences are great—can add feelings of energy and excitement to a design.

Note how two of these three designs play up the importance of just one word, and how one of them highlights two words equally. The correct solution for any logo depends on the goals you and your client are after in presenting it to the world. You can help your client solidify these objectives through the range of ideas you present to them.

Memphis
Guitar
& Music

MEMPHIS
Guitar
& music

MEMPHIS
GUITAR
AND
MUSIC

Weight and color

Each of the logos above features sets of words from a single
typeface that are presented in identical point sizes. See how
weight and color are employed to bring emphasis to one or
more words within each design.

When you're looking for ways of establishing visual hierarchy
within single-typeface logos, headlines, and word graphics,
consider each of these variables—weight, color, and size—and
think about employing one, two, or all three to bring emphasis
where it belongs.

148

It's a great idea to begin any logo or word-graphic project by simply writing down the words you'll be working with in different case configurations and with different line breaks. What this does is give you a quick set of visual reminders of how your words might be presented as you begin considering font choices, type sizes, and line breaks.

For example, you might be thinking about pairing an especially thin and condensed font with an especially bold and wide font and are wondering how these faces might be applied to your given set of words. You can quickly find out (or at least narrow down your options) by taking a look at your handwritten word-configurations to see which ones seem best able to allow for the fonts' different proportions.

So start here, with handwritten sets of the words you're working with. It'll only take a few minutes to jot them down, and it's very likely you'll find that they speed up and improve your search for both a font and a compositional arrangement for the logo or word graphic you're creating.

As far as deciding on specific fonts for your project, try the following.

Type out some or all of your words using whatever software you'll be using for your piece's creation.

Type them out in the three case configurations shown above: initial cap, lowercase, and uppercase.

Place your words within oversized bounding boxes that will allow their letters to get bigger or smaller—depending on which fonts are applied to them in the next step.

Also, to help streamline the upcoming exploratory work, place your set of words in the upper left corner of a relatively large document. This will leave you with plenty of space to position copies of the words as you begin exploring typeface options.

Now it's time to look at typefaces. This is where you search through your font menu to see which ones might work best for your project.

Do this by making copies of the words you typed in the previous step, going through your font list from top to bottom, and applying any that seem like they have the slightest chance of working out. Sometimes you'll come across clear and expected winners, and other times you'll discover unexpected choices that offer themselves irresistibly well to what you're designing.

If a certain font looks good, keep it within your document and move on to additional possibilities. Keep at this until you've gone through your library of typefaces. This may take some time, but it's time well spent: Afterwards, you'll be left with a document that you can conveniently refer to—and sample from—when you begin assembling your logo or word graphic.

What happens if your typeface menu doesn't provide you with just the right font for the project you're working on? Well, naturally, this might mean it's time to spend time (and possibly money) to expand your collection of typefaces.

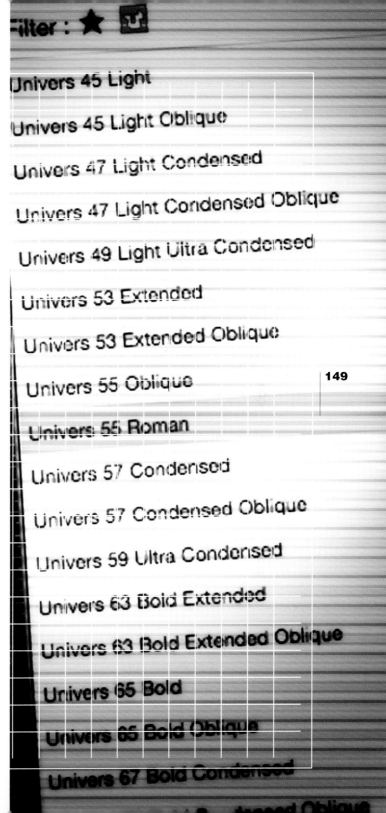

Filter : ★ ⊞

Univers 45 Light

Univers 45 Light Oblique

Univers 47 Light Condensed

Univers 47 Light Condensed Oblique

Univers 49 Light Ultra Condensed

Univers 53 Extended

Univers 53 Extended Oblique

Univers 55 Oblique

149

Univers 55 Roman

Univers 57 Condensed

Univers 57 Condensed Oblique

Univers 59 Ultra Condensed

Univers 63 Bold Extended

Univers 63 Bold Extended Oblique

Univers 65 Bold

Univers 65 Bold Oblique

Univers 67 Bold Condensed

Florence by backpack & bootstraps

A hostel-by-hostel journey to the core of Italy's historical epicenter of art, architecture, food, and espresso.

Florence by backpack & bootstraps

A hostel-by-hostel journey to the core of Italy's historical epicenter of art, architecture, food, and espresso.

150

Color for emphasis

Imagine you're creating a headline and a subhead for a magazine or a website. You've come up with typography that looks good, and now you're looking for ways of adding notes of style and/or emphasis through color alone.

What about coloring just the subhead or just the headline? It's a simple and attractive solution that also helps the design's two main components differentiate themselves.

How about using a bright accent color to bring emphasis to a single word—especially if that word is likely to attract notice and act as bait for further reading?

Note, also, that gray has been used to shade this example's subhead—a ploy that adds a subtle degree of visual complexity to the design.

Don't use just any good looking hue when adding color to type. Color should not only look good, it should also echo meanings and feelings that are being communicated through a design. The head/subhead examples on this spread have been adorned with the national colors of Italy: green, white, and red.

Florence
by backpack
& bootstraps

*A hostel-by-hostel journey
to the core of Italy's historical
epicenter of art, architecture,
food, and espresso.*

Florence
by backpack
& bootstraps

*A hostel-by-hostel journey
to the core of Italy's historical
epicenter of art, architecture,
food, and espresso.*

151

Things are turned around here as black is used as a background for white and colored type.

The headline/subhead presentation above gains an extra measure of visual flair through an unconventional application of alternating colors within its first word and also through its use of three colors within the following two lines of type.

On a technical note, the red that appears on this page is slightly lighter than that used on the previous page. This page's red was lightened to help it stand out better against its black backdrop. Be attentive to adjustments like these whenever applying color to type.

And what about a less intuitive application of color within your headline/subhead? In this case, an unexpected item is highlighted within the subhead to bring attention to certain words deemed more worthy of attention than the headline itself.

Note also that most of this design's subhead is a light gray. Not something that readers would necessarily notice right away, but still a treatment that helps the headline and subhead stand apart from each other.

TYPE AGAINST BACKDROP

Type is almost always there to be read. Sure, there are times when words or characters are set on a page purely as a visual backdrop or as peripheral matter, but those cases are relatively rare. The rest of the time, type needs to be presented clearly and legibly.

Which brings us to the topic of type-over-backdrop. Few things can interfere with the legibility of an other-wise perfectly readable headline or block of text than a visually competing background color, image, or pattern. It's very important, then, that you take whatever steps are needed to maintain the legibility of the type you set over a backdrop of any kind.

The good news here is that while digital media makes it easier than ever to place text over poten-tially troublesome colors, images, and patterns, it also provides designers with tools to solve just about any readability issue that comes up.

When discussing strategies for type legibility, it's important that you fully understand the meaning of the term *value* as it relates to art and design. Value is how light or dark a color or a shade of gray is. A deep burgundy has a dark value. A pale blue has a light value. And the key to maintaining the readability of type that's set over a backdrop is to make sure that there are strong differences between the value of the type and the value of the backdrop.

This is relatively easy to manage when you're simply setting type over a single-color background. You just have to make sure your type is clearly darker or lighter than the color it's sitting over.

Things get more complicated when type is set over a visually active backdrop—like a photo or a pattern— since the values in these backdrops can vary widely and abruptly. Stay tuned for more advice on handling backdrops such as these as the chapter continues.

152

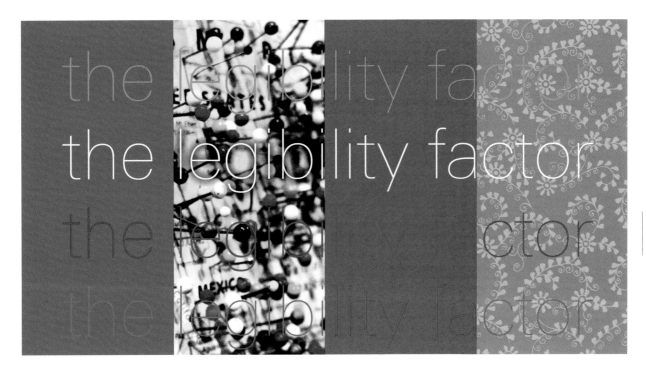

The legibility factor

Just watch as the legibility of the text above rises, falls—and sometimes disappears completely—as it travels from backdrop to backdrop.

Except in the case of the white text, anyway: The white letters maintain their readability as they pass over the busy photograph because of a subtle and value-darkening drop shadow applied between them and the image (see pages 156–157 for more legibility-preserving techniques like this).

Never settle for *almost* when it comes to legibility. Always seek solutions that positively ensure that the text you set over a backdrop color, image, or pattern stands out clearly.

Solid backdrops

Some designers are prone to feel lost when struggling with type-over-backdrop legibility issues. If you feel like you may be one of these designers, turn to this spread the next time you're having trouble: Each of its logos (except for one) presents its type legibly and each has a lesson to offer.

First of all, a reminder: Value is critical (as mentioned on page 152). In the upper sample, dark type and a white line and tittle show up clearly against the mid-value gray backdrop over which they sit.

The lower example works simply by featuring type, line, and tittle that are clearly lighter than their dark gray backdrop.

Get used to seeing value difference whether you're looking at shades of gray or at colors. Painters have a saying: *A color can't be right if its value is wrong.* This is true, always. No exceptions. So take this advice to heart whether you're applying colors to a landscape painting or to a logo design.*

*Color-related advice such as this and much more can be found in this book's Creative Core companion volume, *Color for Designers*.

Maintaining value differences is all the more important when backdrops become more complex, since they may also become more disruptive to type that sits on top of them.

The upper sample is a failure. Why? Because the blue and yellow in the background are so different in value that neither black nor white, nor any shade between, can simultaneously stand out against both colors. As a result, this logo's lower type runs into serious legibility issues.

This problem is solved in the lower sample—not by altering the colors of the type but by lessening the differences in value between its backdrop's colors.

Which isn't to say that there's no way to use the backdrop that failed so miserably in the previous column. At top is a solution where a dark halo was added around the white type, and the logo's line and tittle were changed from black to a light and bright yellow.

And what about adding a translucent layer of white between a busy backdrop and the text it holds? If all else fails—or if you're simply a fan of this look—then this might be the solution you're looking for when dealing with a busy backdrop.

Death

156

Type over imagery

Here are ways of placing readable text over a visually active backdrop (an image, in this case). For starters—as shown in this column, and picking up where the previous page left off—you could put a translucent white (or lightly colored) panel between your text and its backdrop image.

The yellow header at the top of this page demonstrates how making type extra-large is another way of maintaining legibility. The mid-value yellow used to color this type would hardly help small text stand out against this spread's photographic backdrop, but the hue succeeds here through a combination of its brightness and the image-spanning size of the type it fills.

You can use black—and dark colors—to create legibility-protecting panels for reversed type. Panels such as these can be presented as solids or as translucent shades.

Be opportunistic, too, when looking for ways to set type over busy background images. See the line of white type at the upper left corner of this page? Notice how the type is positioned just above some mountain tops before threading its way through a convenient gap in the clouds? This is no accident: The background image was placed in just such a way as to allow things to work out like this (and, in all honesty, Photoshop was used to remove one small cloud that originally stood in the way of the type's path).

Valley

157

It's relatively easy to feature type in vacant areas of a photograph—as demonstrated here.

And then there's the trick of adding a light glow around dark type that sits on top of an active backdrop...

... or a dark glow around light type that does the same. (Also note that this white type is a step bolder than the dark type directly above—and this also helps with legibility.)

Bigger and bolder type, presented with a black, white, or colored outline, might also work if you're okay with louder projections of personality.

Original image

158

downtown

The previous spread demonstrated ways of treating and assisting type to safeguard legibility. Here, the focus is on ways of altering photographs to do the same.

Pretty much any designer can benefit from an understanding of basic Photoshop tools and effects. And that's all that's been called upon here to keep the headline in the three examples at right clear and readable in spite of the visually active photo they're sitting over.

New to Photoshop? Two of the first things you should become acquainted with are adjustment layers and layer masks. Adjustment layers are layers that don't contain images but rather apply effects to whatever sits beneath them (effects that darken, lighten, alter colors, and much more). Apply layer masks to adjustment layers to control exactly where their adjustments show up. The three sets of samples to the right were created using layer masks and show how various adjustment layers affected the original image shown above.

Want some practice working with adjustment layers and layer masks? Try the exercises on the next spread.

In this sample, an image-darkening CURVES adjustment layer was applied to the image. A gradated window was created at the bottom of the adjustment layer's mask to produce the effect shown at top. The headline type is now visible, and otherwise would have been difficult to see against the image's complex visual content.

Keep in mind that you can also apply these headline-protecting treatments when adding blocks of text to photographs.

An opposite strategy was used to handle the look of this image: A lightened area was created at the top of the photo to preserve the legibility of a headline that would have otherwise struggled for clarity.

Photoshop provides a strong set of controls for modifying the effects of adjustment layers and their masks. Each treatment on this spread could have been made either more subtle or more pronounced with only minor changes to their settings.

The left side of this image was neither darkened nor lightened. In this case, it's values were confined to a mid-range of grays using both a CURVES and a HUE/SATURATION adjustment layer. The resulting backdrop-area provides a perfect setting for the placement of a colored headline.

This image-plus-type exercise has as much to do with altering photographs as it does with working with type. And why not? Designers regularly find themselves melding photos with type when creating layouts, and image-related skills often need to be applied hand-in-hand with typographic know-how.

160 | **Exploring type-over-photo solutions**

The instructions for this project are simple. Select a few favorite photos from your personal cache (you do have a sizable personal cache of digital images, right?), open the images in Photoshop, set some type over the top of your images, and then use adjustment layers and their layer masks (mentioned at the start of the previous spread) to protect the legibility of your word(s).

What sort of text could you add to your photos? Take a look at the facing page for ideas.

In addition to adding adjustment layers to support the legibility of your type, also be open to trying out any other Photoshop effects you think might be of help. (You could apply effects directly to your text, too, as talked about on pages 155–157).

If you're brand new to Photoshop or your experience with this program is limited, this might be a great time to go through a tutorial that covers things like adjustment layers, layer masks, blend modes, and special effects (alternatively just consult the Help menu and figure things out while you work on this project).

Not only will this exercise give you ideas for future client-based jobs, it'll also stock you with possible solutions the next time you want to create a custom-made card for a friend, a piece of wall-art for your office, or a purely artistic weekend project.

Ideas: How about adding the name of a person, place, or thing to your photo? Or what about adding a favorite passage of text, a brief comment, or a journal-like entry?

ABOVE BOSTON

"I don't care how many bugs there are in the sunflowers," she said. "If Van Gogh liked sunflowers, then so do I."

The Last Day in August
JAMES EDWARDS

Going it alone.

Finally. 2pm. No time for a break, but absolutely time for a double-short latte with a sprinkling of cocoa on top. Yes. Finally.

LOGOS THAT INTEGRATE TYPE AND ICON

Logos can be created using only typography, or they can be designed to include an icon.

Type-plus-icon logos are the focus of this spread and the next. And since designers are very often asked to create logos like these, it wouldn't be a bad idea to have your own strong and adaptable plan-of-action that you can go to whenever you're asked to develop a set of designs for presentation. Got such a plan? If not, consider shaping the routine described here into a plan you can apply to upcoming projects.

Start by talking to your client and finding out as much as you can about their hopes and expectations for the project. Best to know these things right up front since information like this can guide you toward solutions that have a good chance of selling while also steering you away from ones that probably won't.

Get to to know your target audience, too. Your final design will have little value if its target audience isn't wowed by it—regardless of how much you and your client love it.

Next, brainstorm for both visual material and thematic inferences that might be at home in your logo. See pages 108–109 for more on this process.

Once your brainstorming has churned up some useful thumbnail sketches and given you a strong sense of direction, go to the computer to create your icons and to select just the right fonts for your designs.

From there, explore all kinds of different arrangements between the icons you've developed and the fonts you've selected. (Use the visuals and text on the next three pages to help you brainstorm for solutions during this stage of the project.)

Once you finalize your logo's compositions, apply color and make any finishing touches needed to complete your designs.

BOREALIS
ACOUSTIC INSTRUMENTS
AUSTIN TEXAS

Borealis
Acoustic
Instruments
AUSTIN TX

Basic associations

Icon-over-type and icon-next-to-type associations between a logo's elements may be commonplace, but they shouldn't necessarily be dismissed for lack of originality. After all, logos built in this tried-and-true manner can look beautiful and function quite nicely.

The main thing to keep in mind when working with these kinds of arrangements—or any of the several others featured on the following two pages—is to make sure your icon and type aren't fighting for attention. Establish visual hierarchy by making one larger, bolder, and/or more colorful than the other. That way, viewers' eyes won't have a hard time knowing which to go to first when they come across your design.

164

Considering options

Above, below, alongside, within, behind, or in front? Exactly where should my icon sit in relation to my logo's type? Can my icon be used in place of a letter? Can it sit within a space between words? Should it be more colorful than the type? Should it appear faded and restrained?

Ask yourself questions like these whenever you're developing a type-plus-icon logo. Use the computer extensively to put potential solutions in front of your eyes and to give your designer's mind plenty of material to consider when picking favorites.*

*Designers commonly present clients with three to five designs during the initial stages of a logo project. Ideally, each of the designs will convey itself differently than any of the others, and each would work beautifully if it were chosen by the client. Well-prepared designers might also bring a laptop to the meeting that holds variations to one or more of their designs...just in case.

Explore, explore, explore. What about wrapping your type all the way around the icon you've designed? How about framing your icon with type that arcs both above and below it? How about adding a backdrop panel to your design? And what about developing a more complex enclosure/emblem style of logo—something that might look especially attractive when silkscreened on a T-shirt or printed on vinyl as a vehicle graphic? (See pages 116–117 and 177–179 for more about emblem-style logos and word graphics.)

LAYOUTS AND GRAPHICS

When things go just right within a layout, it's usually because its typography, imagery, design elements, and textual content are contributing successfully toward in-common visual and thematic goals.

Given that this is a book on typography, this spread and the next focus mostly on the role type plays within this formula for success. This discussion mentions, however, other visual material and abstract concepts since typography must very often collaborate with these kinds of things in order to do its job effectively.

Much more will be said about typography and page compositions in the final chapter, Text and Layouts, beginning on page 182. But here you'll get a good head start on later material by seeing how visual hierarchy comes into play whenever headlines, imagery, and text share space together.

Also, even though the examples on the next three pages have to do with headlines, imagery, and blocks of text, you can adapt and apply their lessons to layout scenarios of many different sorts.

For example, even though the facing page gets into a discussion of how conceptual matters might affect how visual hierarchy is established through a layout and its headline—know that the idea presented there can be easily adapted to logos, signage, packaging, and word graphics. And the examples of compositional visual hierarchy on the next spread, well, with a little imagination, their lessons can be applied to pretty much any work of art or design you create—whether or not they include type.

Making your point.

Questions and answers

Working on an advertisement or a brochure? Brainstorming ways of presenting a headline? Ask yourself, *What's the point?* As in, *What's the point of this piece? What's its message? How is that message supposed to come across?* And, as your layout starts coming together, ask, *Is my headline speaking in the right typographic voice? Is it connecting conceptually with the piece's imagery? Does it stand out properly against other compositional elements? Would a different font, different size, or different color help it call for just the right amount of attention?* Try to answer each of these questions, not only as a designer but also as a target-audience member. Listen carefully to whatever responses come to mind and act accordingly.

Establishing pecking order

Use this spread as a tool. Turn to these two pages the next time you're working on a layout and let these images spur you toward compositions that position your layout's components at targeted levels of the visual hierarchy spectrum.

Take a look, for instance, at compositions that give strong visual precedence to your headline, to a single word within the headline, to the piece's image, or even to white space that's been granted the greatest amount of visual real estate within the layout.

This is the headline

Lorem ipsum dolor sit amet, nec lorem non, turpis aliquet id nulla fusce bibendum, pulvinar pellentesque pede nisl libero. Ut ultrices libero, luctus metus id accumsan, ut vitae dictum mollis ipsum proin, eros duis amet in sed per sociis, elit consequat est vitae.

Vel massa nisl omnis justo turpis orci, quisque ultricies donec, justo orci, vestibulum velit suspendisse porta et. In donec mi ultricies eget integer, nulla gravida wisi nunc id nullam. Auctor ligula montes fusce, nostra proin massa, erat facilisis massa, phasellus non taciti duis nulla. Fusce potenti congue diam aliquam. Vel aenean leo wisi, quam quam. Sem tincidunt et gravida mauris imperdiet, porta vulputate, et nemo lectus ut neque donec, velit vivamus auctor donec unde lorem. Duis arcu assumenda eros nisl nec eleifend, sapiente erat aliquam bibendum donec convallis mauris, consectetuer amet

mauris, leo quis in neque risus et eu. Orci ac ut velit est sociis, ligula egestas suspendisse fermentum elit nunc, quisque sed cursus tellus proin. Tincidunt nibh mollis vel in. Tellus sollicitudin, rutrum vitae tempor amet, sed magna porttitor torquent ligula massa, dolor id eu erat. Ante tellus wisi commodo lorem orci, nulla id eget pulvinar. Commodo porta consequat eget cursus eget erat, pulvinar eleifend, scelerisque ipsum suspendisse pede in rhoncus in, eget sem, amet mauris sed erat nunc convallis. Libero accumsan consectetuer, molestie in massa.

Neque phasellus augue arcu maecenas duis dui, phasellus aliquam eget egestas tristique orci neque. Sodales molestie lectus tellus tempus molestiae, nunc eros mollis dolor, ut convallis molestiae pellentesque eget lorem, iaculis elit consectetuer posuere eros. Risus nisl vestibulum integer, ultricies aliquam.

LOGO

Sameness

The visual strength of this layout's headline, image, and text block are relatively similar. Too similar, in fact, to be used as any kind of example of visual hierarchy.

Usually, it's best to avoid visual sameness within layouts since a lack of visual hierarchy can come across as uncharismatic and indecisive. Sometimes, however, visual uniformity is a perfect thing to aim for—as when you're creating a layout that's meant to present itself without strong hints of personality. If you do decide to pull back on the visual hierarchy within a layout, just make sure the design scores well in terms of its overall attractiveness—otherwise viewers may find no real reason to be drawn into its message.

Corporate logo design, with icon

This project is a lot like the logo-creation exercise on page 143, except this one involves a slightly more common scenario—one where a client is specifically asking for a set of logo ideas that include an abstract icon along with the name of their company.

170

Here, the client is *Renaissance Contemporary Interiors*. The company specializes in affordable but upscale-looking interior design projects. The client has asked that you come up with a purely decorative icon (something in the general direction of the icon used for the samples at right), and then show three different ways that the icon could be combined with the company's name. Also, the client has asked that each of your designs be targeted toward a demographic with sophisticated—though also fairly conservative—tastes in art and design.

Use the same icon for each of your logos, but apply notably different typographic and compositional solutions to all three designs. Vary fonts, line breaks, type/icon arrangements, color usage, and applications of visual hierarchy among your designs.

Start your project by developing the decorative icon for your logos. Create something from scratch, or borrow a piece of decor from a family of typographic ornaments and use it as the basis for your icon (as was done for the design seen at right).

Once your icon is finished, start looking for fonts that pair well with its look, and also explore various ways of arranging all of your designs' elements. Use the samples at right to help generate ideas in this regard, and also look to printed and posted collections of logos for inspiration. Make quick thumbnail sketches of your ideas before moving to the computer to finalize your three most promising and visually varied ideas.

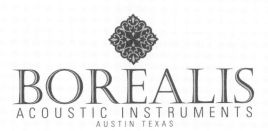

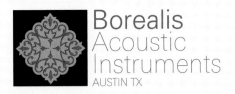

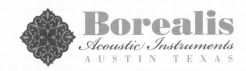

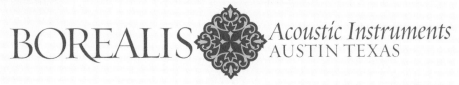

All type

Enough about imagery for a few pages. What about letters and words that work either alone or with a simple backdrop panel? Typographic structures that are themselves communicative and attractive standalone images?

This is a fun area of exploration for designers who love type—as most designers do. Use this spread and the next as brainstorming fuel the next time you see a chance to create a graphic from words.

For starters, how about going subtle? The letters of the sample above are actually invisible—it's only their light gray outer halo that defines their presence on the page.

Special effects, anyone? Illustrator and Photoshop offer plenty of choices when it comes to making letters and words blurry, transparent, skewed, rippled, bent, twisted, pixelated, or roughened up.

This design's headline ignores convention and travels bottom-to-top rather than the usual left-to-right; its initials are used for the blurred stack of characters below; and the overall design is configured in a way that might bring notions of a flag or a banner to mind.

SEATTLE
CONTEMPORARY
ART
COLLECTIVE

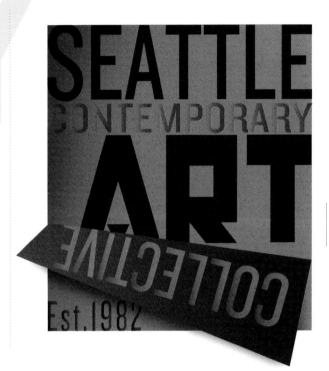

The dimensional treatment applied here (accomplished with Illustrator's FREE TRANSFORM tool) and its use of Futura Bold lend notes of mid-20th-century design to this composition. It's a look that's bolstered by a shade of blue-green that would have appeared right at home on trendy dinnerware, clocks, and automobiles of that era.

In this sample, a constructivist-looking display font at center, muted and graduated colors throughout, and a touch of faux dimension add up to a design reminiscent of WPA (Works Progress Administration) posters of the 1930s.

How era-aware are you about typography and design? There's much inspiration to be had, and much to be learned, by looking backwards and seeing what designers were up to in times gone by. Bookstores (including those with a good selection of used books), libraries, and websites are great sources for material like this.

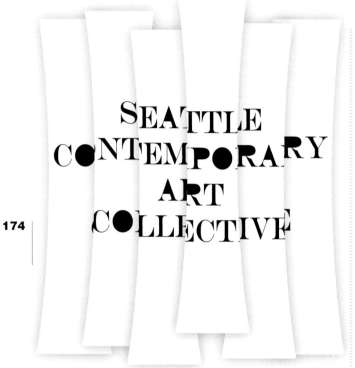

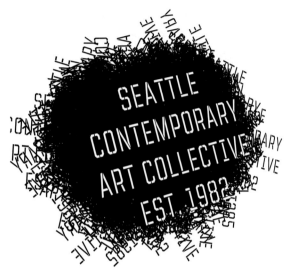

174

All type (continued)

Legibility is always king, but yes, there are situations where its kingliness can be challenged. For example, this piece might be allowed some leeway in terms of readability since it's aimed at an art-minded audience that's probably spent plenty of time looking at nonrepresentational freeform sculptures, expressionist landscape paintings, and abstract portraits.

And really, when you first saw the typography in the above sample, were you all that challenged by it? Probably not. Sometimes legibility can be surprisingly robust, and other times it's the most fragile component of a design. Listen to your designer's instinct on this one.

Type upon type upon type. Even the backdrop in this sample has been built from dozens of layers of overlapping words.

What about sticking to an ultra-strict all-type regimen like this when designing a word graphic? Your backdrop, line-work, decor, and border elements could all be made from typographic characters.

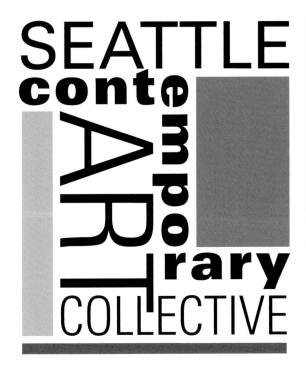

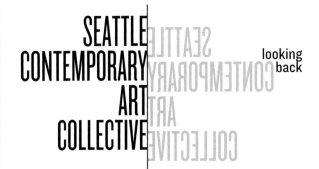

Here, three colored rectangles have been allowed into a composition that—truth be told—started out with the goal of being purely typographic. It just felt like the thing to do—to fill the spaces with colored boxes—when the crazy configuration of type created a few open spaces that begged for filler.

Be open-minded and open-eyed to unexpected and opportunistic solutions to all your design projects—type-related and otherwise. Just because you started a project with a certain set of rules in mind doesn't necessarily mean you can't break those *rules* if a good enough reason comes along. After all, aren't rules made to be broken? Especially when it comes to expressions of creativity?

A subtitle has been added to this design, and, accordingly, some of the logo's other type has been turned backwards to reflect the subtitle's meaning.

It's interesting how typeset words can deliver ideas and feelings—not only through their literal meaning and through the persona of their font—but also through how they are oriented, scaled, positioned, and colored. Design has many, many ways of delivering messages and emotions to viewers: Be ever open to possibilities that lie outside realms of *normal, expected,* and *status quo.*

ENCLOSURES AND ASSEMBLAGES

Enclosures were mentioned in the previous two chapters, and they come up again here. Given that this is a book on type, why so much focus on not-purely-typographic creations like these? It's because an enclosure can be to typography what a frame is to a work of art or what a stage is to an actor: an attractive partition against the rest of the world that acts as a venue for creative expression.

Often, enclosures are designed to unobtrusively frame the type they hold. Sometimes they're allowed to contribute feelings of personality to similarly expressive type. And there are also cases where an enclosure is asked to do *all* of a design's theme-setting work while wrapping around type that speaks in an impartial voice (a good example of this would be when a relatively neutral typeface like Helvetica is used within something like a starburst design filled with a lively pattern of bright colors).

The enclosures shown on this spread are basic and simple. None took much time to create, and none took much planning or forethought to figure out. But still, each of these enclosures bring conveyances of unity, purpose, style, and containment to the words they hold.

It goes without saying that not all typographic logos need to be enclosed by linework, ornamental decorations, or backdrop panels. But what's it really going to take to find out if the logo you're working on might be improved by additions like these? Thirty seconds? A minute? Five minutes? Worth a look, right? And what determines if an enclosure should stay or if it should go? Your art sense, your awareness of current trends in design, and, possibly, the approval (or lack thereof) of your client.

GREGOR DUNCAN AND JEFFREY

Simple enclosing strategies

Imagine removing the linework, ornamentation, and backdrop panel used to enclose these three logo designs (and while you're at it, imagine the type in the lower example changing to black, since otherwise it would become invisible). Each logo would survive and work just fine as a purely typographic design, but each would be different, and each might also lose the very stylistic touch that sets it apart from competitors' logos and makes it especially dear to the client.

Evaluating whether or not an enclosure is needed for a typographic logo is a task that must be handled on a case-by-case and client-by-client basis. And the criteria for evaluation will be different in each situation since it's bound to be mostly governed by stylistic preferences, which, as we all know, changes within ourselves over time, just as it changes for our clients and our target audiences.

In addition to matters of style and personal preference, there may also be practical considerations that tip the scales either for or against adding an enclosure to a logo. For example, you may learn that a client's logo will often appear within crowded small-space ads—in which case an enclosure might be a handy feature in providing a clear boundary between the logo's type and any encroaching text or graphics.

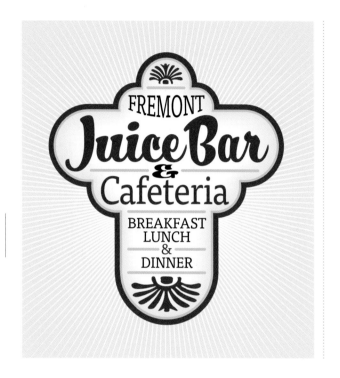

Going further

Above is a fairly involved graphic assemblage—and something that not only stands a good chance of catching viewers' attention, but also of providing them with pieces of information that are usually missing from less wordy logo designs.

The interior gradations of color within this logo, as well as its radiating pattern of exterior lines, give this design a glowing-from-within appearance and a warmly energetic demeanor. (The exterior lines, by the way, could be considered an optional feature of a design like this—a feature that could be included when there's space for them, and left out when there's not.)

Multiple appearances of circles in the design at top help it connect to a *gumball* theme (circles were also used to carve out the expressive ring of outward-gesturing shapes around the logo's perimeter.) The design's central type features oversized first and last letters that help the word conform to the shape of its own sub-enclosure, and the logo's mixture of fonts generates feelings of earlier times when multi-font configurations were the rule of the day.

The lower sample features an illustrative enclosure that lends clear feelings of history and formality to whoever Charles Stanley is, and whatever his company does (not all logos reveal these details up front).

Purely typographic solutions

At top is an interesting variation of the enclosure theme. In this case, two lines of type are used to enclose—from above and below—another typographic element and two illustrated designs. The resulting assemblage holds together well as a composite visual.

The other example in this column is a purely typographic assemblage that also delivers itself in a compact and cohesive way. If desired, you could further emphasize the tight-fitting look of a logo like this by wrapping the entire design with a close-fitting backdrop panel.

Nothing but type: words wrapping around and crossing paths with other words.

You'll likely need a company's slogan, its address, or information about its product to build up a sufficient word count for a design like this. Consider your options and check with your client about some possibilities.

YOUR TURN TO: **CREATE A PERSONAL EMBLEM**

Now it's your turn to come up with a personal emblem—a design that includes your initials*, your spelled-out name, or the name of a club or a business you're involved with.

And by *emblem*, what we're talking about here is a compositional construction that is more or less along the lines of the samples on the previous two pages (as well as on pages 116–117). Your own design could feature decorations, patterns, illustrations, photography, background panels, and/or enclosing linework along with typographic elements. Or it could be made entirely from type.

Start your design process by thinking of the kinds of visual and thematic projections your creation should deliver (see pages 108–109 for brainstorming tips).

Next, move on to the thumbnail stage and try to give yourself three to six sketched-out ideas to consider. Then, act as your own client and choose your favorite for further development on the computer.

Use whatever software suits your project best as you work toward finalizing your design. Also, even if you're working from a tightly rendered thumbnail sketch, be open to changes and improvements that come to mind as you work on the computer. Make sure to try out a variety of font choices before making up your mind, and also look into all kinds of compositional, decorative, and color-based finishing touches for your emblem (and don't forget to save copies of any promising solutions as you work to avoid making irreversible changes to a design that might have been your best).

What to do with your finished emblem? Up to you, of course. How about hanging a copy on the wall of your office or art space? What about printing some stickers? Or maybe doing a limited run of personal or professional calling cards?

*You may have already come up with an interesting monogram for yourself after doing the exercise on page 80. If so, you can now incorporate that design into the emblem you create here.

Always remember when designing emblem-like logos like these to take advantage of the workflow-boosting capabilities of software and to investigate different ways of finishing your design.

And why not? You've got nothing to loose, and possibly much to gain, by looking into as many alternate endings for your project as possible before calling it done.

Here are three different color variations to an emblem borrowed from the previous spread. Each could be considered a final product, and it would be up to you and the client to decide which is likely to appeal best to the target audience.

Variations in typefaces could (and usually should) be investigated as well when working on an emblem-like design, as could options involving its structure and the arrangement of its typographic and decorative components.

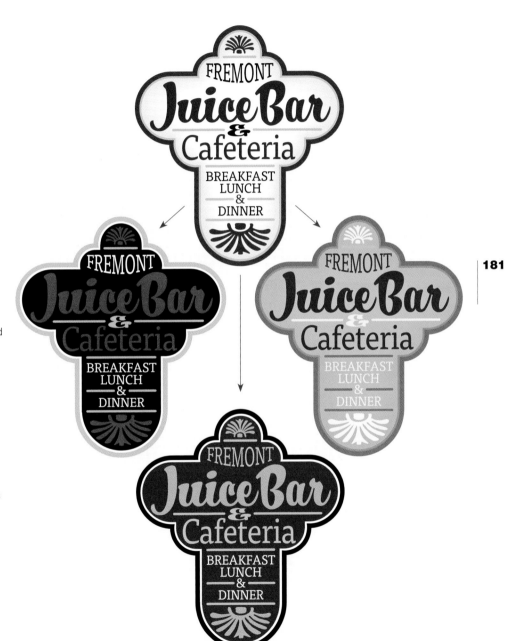

181

Text and Layouts

HELPING THE READER READ

Once again, a reminder that type that can't be read is type that isn't doing you, your client, or your target audience any favors. Readability is a top priority when it comes to presenting words through design.

As mentioned on page 91, legibility is a subjective call. Typefaces that one group of people finds easy to read might challenge and irritate others. And text that's plenty big enough for people with 20/20 vision might be impossibly small for people with less accurate eyesight. A good rule-of-thumb is to play it safe—to choose fonts and present text in ways that leave nothing to chance. Consider showing a draft of your layout to a few members of your target audience if you have any doubts about the design you're creating.

Also, don't rely on your on-screen view of a headline or a block of text to tell you whether or not the type in your for-print layout is being presented readably. After all, your monitor is almost always showing you either an enlarged or a reduced view of things, and sometimes its presentation of color and clarity are overly optimistic. So print it. Print a sample of your layout using a good-quality printer before getting too deep into its development. Hold your printed proof at reading distance and ask yourself, *Is this type easy to read? Is it neither too large nor too small? Is there anything else in this layout—like a backdrop image or an encroaching compositional element—that interferes with the readability of the type I'm looking at? What would my target audience think?*

Typography is a game of subtlety. Tiny differences between typefaces can generate large variances in the personas they lend to layouts, and can also affect how easily a layout's type can be read. Opposite are a set of notes regarding both the look and the function of a handful of typefaces applied to a column of text. Use these notes to help kickstart your own awareness of some of typography's finer points.

Baskerville

There is little mistaking the sound of a pileated woodpecker in the forest. Its call is unique among birds who share the same habitat, and the din generated when its stout beak hammers against a tree is significantly louder and more punctuated than that produced by other birds who peck at wood for food and shelter.

Bodoni

There is little mistaking the sound of a pileated woodpecker in the forest. Its call is unique among birds who share the same habitat, and the din generated when its stout beak hammers against a tree is significantly louder and more punctuated than that produced by other birds who peck at wood for food and shelter.

Tisa

There is little mistaking the sound of a pileated woodpecker in the forest. Its call is unique among birds who share the same habitat, and the din generated when its stout beak hammers against a tree is significantly louder and more punctuated than that produced by other birds who peck at wood for food and shelter.

Quench

There is little mistaking the sound of a pileated woodpecker in the forest. Its call is unique among birds who share the same habitat, and the din generated when its stout beak hammers against a tree is significantly louder and more punctuated than that produced by other birds who peck at wood for food and shelter.

Helvetica Light

There is little mistaking the sound of a pileated woodpecker in the forest. Its call is unique among birds who share the same habitat, and the din generated when its stout beak hammers against a tree is significantly louder and more punctuated than that produced by other birds who peck at wood for food and shelter.

Reykjavik

There is little mistaking the sound of a pileated woodpecker in the forest. Its call is unique among birds who share the same habitat, and the din generated when its stout beak hammers against a tree is significantly louder and more punctuated than that produced by other birds who peck at wood for food and shelter.

Baskerville Regular

There is little mistaking the sound of a pileated woodpecker in the forest. Its call is unique among birds who share the same habitat, and the din generated when its stout beak hammers against a tree is significantly louder and more punctuated than that produced by other birds who peck at wood for food and shelter.

Helvetica Roman

There is little mistaking the sound of a pileated woodpecker in the forest. Its call is unique among birds who share the same habitat, and the din generated when its stout beak hammers against a tree is significantly louder and more punctuated than that produced by other birds who peck at wood for food and shelter.

Text font considerations

Baskerville, a transitional serif face with a pleasant and predictable flow of variations among its characters, is ultimately easy on the eyes as a text font.

Bodoni can also work for text, but note how the distinct differences between its thicks and thins amount to a somewhat raspier and less flowing visual voice.

Tisa, a contemporary serif typeface, trades a measure of grace for notes of both informality and sturdiness.

Quench, another modern face, though an okay choice for small bits of text, might not be well suited for lengthy passages since its slightly quirky persona might become tiresome when viewed in large amounts.

Serif fonts might be the better choice for large masses of text since their horizontal serifs helpfully guide the eye along lines of words.

Still, cleanly designed sans serif fonts (like the two shown above) are also viable choices for text—especially when only small or moderate amounts of words are being presented.

It can be risky to reverse serif type from black or colored backdrops since their serifs and fine strokes might partially (or completely) fill with ink.

Serif fonts of medium weight and above might be a safer choice when it comes to reversing text.

All three Grand Downtown Guest Houses are renovations of large-scale San Francisco homes built between 1895 and 1910. Significant interior and exterior details of the common areas of each guest house have been painstakingly retained and restored, and individual rooms have been refinished to authentically reflect the era in which the homes were built.

All three Grand Downtown Guest Houses are renovations of large-scale San Francisco homes built between 1895 and 1910. Significant interior and exterior details of the common areas of each guest house have been painstakingly retained and restored, and individual rooms have been refinished to authentically reflect the era in which the homes were built.

All three Grand Downtown Guest Houses are renovations of large-scale San Francisco homes built between 1895 and 1910. Significant interior and exterior details of the common areas of each guest house have been painstakingly retained and restored, and individual rooms have been refinished to authentically reflect the era in which the homes were built.

Tracking

In typography, tracking refers to the spacing allowed between the letters within words as well as between words within an area of text.

Tracking should not to be confused with kerning, which generally relates to the targeted spacing between individual pairs of letters within a word.

The top example on this page has very tight tracking—too tight for most people's visual comfort. Ultra-tight tracking should be avoided unless there's a legitimate style-related reason for using it.

The middle sample is set with default, neutral tracking and is nicely readable. This level of tracking is perfect for most presentations of text.

The wide tracking of the lower sample provides no real challenges to legibility, though it would make readers' eyes work a little too hard if it were applied to a large amount of text. Tracking like this might be appropriate for small captions that are meant to come across as either relaxed and genteel or offbeat and quirky—depending on the personality of the font being used and the context of the message being presented.

All three Grand Downtown Guest Houses are renovations of large-scale San Francisco homes built between 1895 and 1910. Significant interior and exterior details of the common areas of each guest house have been painstakingly retained and restored, and individual rooms have been refinished to authentically reflect the era in which the homes were built.

All three Grand Downtown Guest Houses are renovations of large-scale San Francisco homes built between 1895 and 1910. Significant interior and exterior details of the common areas of each guest house have been painstakingly retained and restored, and individual rooms have been refinished to authentically reflect the era in which the homes were built.

All three Grand Downtown Guest Houses are renovations of large-scale San Francisco homes built between 1895 and 1910. Significant interior and exterior details of the common areas of each guest house have been painstakingly retained and restored, and individual rooms have been refinished to authentically reflect the era in which the homes were built.

All three Grand Downtown Guest Houses are renovations of large-scale San Francisco homes built between 1895 and 1910. Significant interior and exterior details of the common areas of each guest house have been painstakingly retained and restored, and individual rooms have been refinished to authentically reflect the era in which the homes were built.

Leading

Leading is the distance between the baselines of stacked lines of type. Here, 10 point type has been set with 10 points of leading. Solid leading* can be applied when space is limited, though it may cause type to look a bit cramped.

*When leading and type are the same size, they're referred to as being set *solid*.

This is negative leading. Here, 10 point type has been set with only 8 points of leading (verbally described as *ten over eight*, or printed in fraction-like form as *10/8*). Negative leading is not usually applied to text since it can result in collisions between letters from line to line but it might be a good choice for carefully handled headlines or logos.

This block of text is set 10/12 (10 point type with 12 points of leading). A well chosen font, set with relaxed leading of this sort, comes across as comfortable to the eye and easy to read. Space constraints don't always allow for ideal amounts of leading but it's usually something to strive for.

The 10/16 presentation in this sample gives it an airy feeling of lightness. Elegant fonts, set in this way, can take on additional notes of grace and ease. Space permitting, leading like this can be a good choice for both short and long presentations of text (and it can also be used to help a layout's text take up more space when needed).

Hyphens within text are okay, but too many hyphens can irritate the eyes and brains of viewers by making them work too hard. Hyphens are rarely needed when the right font, at an ideal size, is placed within an adequately wide column.

Type that's considerably too large for its column has to resort to excessive hyphenation in order to fit. A designer should never ask readers to accept this much hyphenation.

Robert Bringhurst, in his highly regarded *Elements of Typographic Style*, states that a line in a column should be able to hold 45 to 75 characters for good reading comfort when larger amounts of text are being presented. This number might go as low as 40 for dense multicolumn work. Use numbers like these as starting places when deciding on column widths and type sizes, and make exceptions when your designer's eye tells you it's okay.

188

Even if the eye is able to follow a line of text from one end of a wide column to another, it will probably be challenged when it's asked to return to the left edge of the column and figure out where the next line starts. This is especially true with blocks of text that run any deeper than this one. Best not to do this to readers. Instead, break your layout into columns of shorter measure.

Column width versus type size

It's very important that you don't set text into a layout in ways that discourage reading. Font choices, font sizes, tracking amounts, leading measurements, column widths, and justification settings all must be taken into account when making sure that the text in your layout can be read with ease.

Take a look at the column-related advice offered by—and demonstrated through—the four blocks of text above.

Flush left	Justified	Flush right	Centered
Achilles' role in the Trojan War is told in Homer's Iliad. The epic opens as Achilles is pulling out from the battle, having been dishonored by the commander of the opposing forces, Agamemnon. The circumstances of his retreat are complex—as one would expect them to be considering the cast of characters involved.	Achilles' role in the Trojan War is told in Homer's Iliad. The epic opens as Achilles is pulling out from the battle, having been dishonored by the commander of the opposing forces, Agamemnon. The circumstances of his retreat are complex—as one would expect them to be considering the cast of characters involved.	Achilles' role in the Trojan War is told in Homer's Iliad. The epic opens as Achilles is pulling out from the battle, having been dishonored by the commander of the opposing forces, Agamemnon. The circumstances of his retreat are complex— as one would expect them to be considering the cast of characters involved.	Achilles' role in the Trojan War is told in Homer's Iliad. The epic opens as Achilles is pulling out from the battle, having been dishonored by the commander of the opposing forces, Agamemnon. The circumstances of his retreat are complex— as one would expect them to be considering the cast of characters involved.

189

Justification

Flush left and justified are the two most common ways to align text within a column. Flush-left tends to come across as more casual and natural than justified, and is often used for brochures and ads. You rarely see flush-left columns in books, though, since their uneven right edges might upset sought-after projections of consistency from page to page.

Justified text can help make pages look clean and orderly. Be wary of justifying overly narrow columns since large gaps may appear between the words it holds. If you do run into minor problems in this regard, open InDesign's JUSTIFICATION SETTINGS panel and see if you can find a good solution.

Flush-left text might be perfect if you want to add a caption along the vertical left edge of an image. Flush-left text is usually a poor choice for wide columns since the eye will have trouble finding its place along the column's ragged left edge as it moves downward from line to line.

Centered text, like flush left text, can be difficult to navigate in large amounts or when it's placed in wide columns. Still, it can be a practical and attractive way of setting type for things like announcements and business cards where textual material tends to be broken down into short sentences and small bits of information.

The history of toy and model airplanes goes back at least as far as the origins of powered flight. Early aircraft toys were made from wood, tin, cloth, and string. Later, balsa wood and tissue would be used to create actual flying models of airplanes, and plastic became the material of choice for scaled down static replicas of planes meant for both the toy boxes of eager children and the shelves of admiring grown-ups. Aircraft miniatures of all kinds are sold and traded vigorously through the Internet—especially as part of the antique scene where both pristine and well-used metal model airplanes can fetch sky-high prices.

The history of toy and model airplanes goes back at least as far as the origins of powered flight. Early aircraft toys were made from wood, tin, cloth, and string. Later, balsa wood and tissue would be used to create actual flying models of airplanes, and plastic became the material of choice for scaled down static replicas of planes meant for both the toy boxes of eager children and the shelves of admiring grown-ups. Aircraft miniatures of all kinds are sold and traded vigorously through the Internet—especially as part of the antique scene where both pristine and well-used metal model airplanes can fetch sky-high prices.

The history of toy and model airplanes goes back at least as far as the origins of powered flight. Early aircraft toys were made from wood, tin, cloth, and string. Later, balsa wood and tissue would be used to create actual flying models of airplanes, and plastic became the material of choice for scaled down static replicas of planes meant for both the toy boxes of eager children and the shelves of admiring grown-ups. Aircraft miniatures of all kinds are sold and traded vigorously through the Internet— especially as part of the antique scene where both pristine and well-used metal model airplanes can fetch sky-high prices.

Wrapping text

The two most common ways of wrapping text around an object: Precisely follow the object's contours from a small distance, or obey an artificially squared-off path around it (examples of both of these approaches can be seen in the column above).

Sometimes you'll find only one feasible way to wrap text around a particular photo, illustration, or graphic, and other times you'll get to take your choice of several workable options. In any case, however you go about wrapping your text, be wary of any solutions that cause certain lines of type to be cut off in awkward places or to be made too short for the words they need to hold.

Setting a text block in two columns makes it possible to insert an image right in the middle. If you decide to do this, and if your columns are as narrow as those shown above, know that you'll proably have to manually insert at least one or two hyphens and returns among its words to help the type conform to the columns' narrowest lines.

The history of toy and model airplanes goes back at least as far as the origins of powered flight. Early aircraft toys were made from wood, tin, cloth, and string. Later, balsa wood and tissue would be used to create actual flying models of airplanes, and plastic became the material of choice for scaled down static replicas of planes meant for both the toy boxes of eager children and the shelves of admiring grown-ups. Aircraft miniatures of all kinds are sold and traded vigorously through the Internet—especially as part of the antique scene where both pristine and well-used metal model airplanes can fetch sky-high prices.

Best to avoid

This sample above summarizes several of the cautionary notes mentioned earlier in this chapter, as well as a couple of new ones.

(1) Avoid indents that are so small that readers may have trouble seeing them. (2) Gaps between columns need to be large enough to make it clear where one column ends and another begins. This gap is too small. (3) Throughout this text, some lines feature extremely tight tracking, and some contain overly wide word spacing. When this happens, use InDesign's JUSTIFICATION SETTINGS panel to even things out. (4) Oops. Don't forget to wrap text around *all* of a text-wrapped image—and not just part of it. (5) It's usualy best not to leave a word hanging like this when wrap-ping text. Either break the line before the word reaches the image or reposition the image so that this kind of thing doesn't happen. (6) An orphan is a word that sits alone at the end of a paragraph. Orphans should be avoided whenever possible unless the orphaned word is especially long. When you see an orphan like this, find a way to bring one or more of its preceding words down with it, or to bring the orphan up a line. Adjustments to tracking and/or manually inserted returns are your best bet when it comes to handling this issue.

PARAGRAPHS

Paragraphs, like typefaces, are something most people take for granted—and therefore never really pay much attention to until they're given a good reason to do so.

Being involved in design is a very, very good reason to sharpen your attention toward both typefaces and text-formatting details (details that definitely include structuring and presenting paragraphs).

So, even though you may not have seen it coming when you chose to pursue a career in the graphic arts, now is indeed the time to expand your knowlege of design to include text-formatting issues you may have once thought were of interest only to copywriters, newspaper editors, and secretaries. After all, it makes sense to add strong text-formatting skills to your personal résumé as a designer considering it's

you who very often has the final say in how written language is presented to readers through words, sentences, paragraphs, and page layouts.

The paragraph, by the way, really is a great invention. Paragraphs break larger ideas and stories down to bite size pieces; let readers know where one chunk of information ends and where another begins; and lend feelings of organization and cadence to a page.

There are traditional, semi-traditional, and rule-bending ways of opening the first paragaph of a chapter or a block of text (as demonstrated on the facing page) and also of marking the beginnings of new paragraphs within a page (talked about on the next spread). Consider plenty of options when it comes to presenting paragraphs since they offer many unique organizational and aesthetic opportunities.

Like most delicate plants, leafy greens favor fertile soil that drains well. Compost and/or manure works nicely as fertilizer. If planted in the spring or fall, greens will typically germinate within a week or two as long as their soil is kept moist.

Like most delicate plants, leafy greens favor fertile soil that drains well. Compost and/or manure works nicely as fertilizer. If planted in the spring or fall, greens will typically germinate within a week or two as long as their soil is kept moist.

Like most delicate plants, leafy greens favor fertile soil that drains well. Compost and/or manure works nicely as fertilizer. If planted in the spring or fall, greens will typically germinate within a week or two as long as their soil is kept moist.

Like most delicate plants, leafy greens favor fertile soil that drains well. Compost and/or manure works nicely as fertilizer. If planted in the spring or fall, greens will typically germinate within a week or two as long as their soil is kept moist.

LIKE MOST DELICATE PLANTS, leafy greens favor fertile soil that drains well. Compost and/or manure works nicely as fertilizer. If planted in the spring or fall, greens will typically germinate within a week or two as long as their soil is kept moist.

Like most delicate plants, leafy greens favor fertile soil that drains well. Compost and/or manure works nicely as fertilizer. If planted in the spring or fall, greens will typically germinate within a week or two as long as their soil is kept moist.

Opening lines

For starters, let's look at ways that opening paragraphs of a chapter or a block of text can offer themselves to readers.

Among other things, an opening paragraph can: simply start without so much as an indent (this, as mentioned on the next spread, is considered an inarguably acceptable way of presenting an opening paragraph); begin with an enlarged capital that's set in either the same font as the rest of the text or in something different; or start out with an ornate drop capital.

What about opening a layout's text with type that gradually goes from a larger size down to text-size over the course of a few lines? Or maybe employing the ages-old method of initiating an opening paragraph with a few words printed in a small-caps font? (The example in the middle of the column above was set using Adobe Garamond Pro—a typeface that includes small caps fonts.) And how about using color to add a touch of style and to help attract readers to the beginning line of your layout's text?

Joseph Conrad served aboard both sailing ships and steamers for 20 years. He had risen from the lowest rank of crew member to that of captain, when, at age 36, he decided to leave the sea and to pursue a career as a writer.

Friends, literary agents, and publishers expressed doubts upon learning that Conrad—a man who had spoken both Polish and French since childhood, and who had only begun speaking English as an adult—wanted to write in English. Conrad insisted, however, because to him, the English language granted the creative and structural flexibility he was seeking to accurately and fully convey his stories of adventure and human psychology.

Joseph Conrad served aboard both sailing ships and steamers for 20 years. He had risen from the lowest rank of crew member to that of captain, when, at age 36, he decided to leave the sea and to pursue a career as a writer.

Friends, literary agents, and publishers expressed doubts upon learning that Conrad—a man who had spoken both Polish and French since childhood, and who had only begun speaking English as an adult—wanted to write in English. Conrad insisted, however, because to him, the English language granted the creative and structural flexibility he was seeking to accurately and fully convey his stories of adventure and human psychology.

194

Joseph Conrad served aboard both sailing ships and steamers for 20 years. He had risen from the lowest rank of crew member to that of captain, when, at age 36, he decided to leave the sea and to pursue a career as a writer.

Friends, literary agents, and publishers expressed doubts upon learning that Conrad—a man who had spoken both Polish and French since childhood, and who had only begun speaking...

Joseph Conrad served aboard both sailing ships and steamers for 20 years. He had risen from the lowest rank of crew member to that of captain, when, at age 36, he decided to leave the sea and to pursue a career as a writer.

Friends, literary agents, and publishers expressed doubts upon learning that Conrad—a man who had spoken both Polish and French since childhood, and who had only begun speaking English as an adult—wanted to write in English. Conrad insisted, however, because to him, the English language granted the creative and structural flexibility he was seeking to accurately and fully convey his stories of adventure and human psychology.

Denoting new paragraphs

Strictly speaking, it's not necessary, or even advisable, to use an indent for the first paragraph in a chapter or a block of text.

An excellent measurement for the indents of a page's subsequent paragraphs is about 1.5 ems. An em is a flexible unit of measure that equates to the size, in points, of the type being used. As an example, the top paragraph is set in 9 point type; its em measurement, therefore, is also 9 points; and that means its paragraph indent is 13.5 points (9 x 1.5 = 13.5).

With widely leaded text, some designers prefer to use the leading size as an indent measurement. The lower sample, set in 9/18 Baskerville, features an indent of 18 points.

Line breaks can be used in place of indents to denote the beginning of a new paragraph. It's generally considered bad form to use line breaks and indentations together: Choose one or the other.

Double line breaks are a perfect way of denoting fresh paragraphs with centered text since indents can be almost impossible to find when text is formatted in this way. Same goes for flush-right text.

Joseph Conrad served aboard both sailing ships and steamers for 20 years. He had risen from the lowest rank of crew member to that of captain, when, at age 36, he decided to leave the sea and to pursue a career as a writer.

Friends, literary agents, and publishers expressed doubts upon learning that Conrad—a man who had spoken both Polish and French since childhood, and who had only begun speaking English as an adult—wanted to write in English. Conrad insisted, however, because to him, the English language granted the creative and structural flexibility he was seeking to accurately and fully convey his stories of adventure and human psychology.

JOSEPH CONRAD SERVED ABOARD BOTH sailing ships and steamers for 20 years. He had risen from the lowest rank of crew member to that of captain, when, at age 36, he decided to leave the sea and to pursue a career as a writer.

Friends, literary agents, and publishers expressed doubts upon learning that Conrad—a man who had spoken both Polish and French since childhood, and who had only begun speaking English as an adult—wanted to write in English. Conrad insisted, however, because to him, the English language granted the creative and structural flexibility he was seeking to accurately and fully convey his stories of adventure and human psychology.

Joseph Conrad served aboard both sailing ships and steamers for 20 years. He had risen from the lowest rank of crew member to that of captain, when, at age 36, he decided to leave the sea and to pursue a career as a writer.

Friends, literary agents, and publishers expressed doubts upon learning that Conrad—a man who had spoken both Polish and French since childhood, and who had only begun speaking English as an adult—wanted to write in English. Conrad insisted, however, because to him, the English language granted the creative and structural flexibility he was seeking to accurately and fully convey his stories of adventure and human psychology.

Solving the argument

You've heard of an indent, but what about an *outdent?* It's a term you probably won't find in a dictionary, but designers and typographers have long used it to describe the kind of formatting illustrated above.

Outdenting is not a means of paragraph notation that's used very often, but every once in a while you might sense that the job you're working could be a good fit for an out-of-the-ordinary typographic treatment like this. Keep it in mind.

Using an indent for an opening paragraph is frowned upon by many typographic experts. In the past, it was more common to see layouts that allowed opening paragraphs to be indented (especially in books), but it's less and less common these days, and top level designers usually steer away from it. You may find that some clients (and some designers, too) have never noticed this detail of typographic formatting, and, as a result, you might need to educate them if the issue comes up. Feel free to show them this spread of *Lessons in Typography* to bolster your argument in favor of not indenting opening paragraphs (an argument that could be furthered with a copy of Bringhurst's *Elements of Typographic Style*—a book considered by many to be the final word on most typographic matters).

Joseph Conrad served aboard both sailing ships and steamers for 20 years. He had risen from the lowest rank of crew member to that of captain, when, at age 36, he decided to leave the sea and to pursue a career as a writer. ⌇⌇ Friends, literary agents, and publishers expressed doubts upon learning that Conrad—a man who had spoken both Polish and French since childhood, and who had only begun speaking English as an adult—wanted to write in English. Conrad insisted, however, because to him, the English language granted the creative and structural flexibility he was seeking to accurately and fully convey his stories of adventure and human psychology.

Joseph Conrad served aboard both sailing ships and steamers for 20 years. He had risen from the lowest rank of crew member to that of captain, when, at age 36, he decided to leave the sea and to pursue a career as a writer. Friends, literary agents, and publishers expressed doubts upon learning that Conrad—a man who had spoken both Polish and French since childhood, and who had only begun speaking English as an adult—wanted to write in English. Conrad insisted, however, because to him, the English language granted the creative and structural flexibility he was seeking to accurately and fully convey his stories of adventure and human psychology.

196

Joseph Conrad served aboard both sailing ships and steamers for 20 years. He had risen from the lowest rank of crew member to that of captain, when, at age 36, he decided to leave the sea and to pursue a career as a writer. Friends, literary agents, and publishers expressed doubts upon learning that Conrad—a man who had spoken both Polish and French since childhood, and who had only begun speaking English as an adult—wanted to write in English. Conrad insisted, however, because to him, the English language granted the creative and structural flexibility he was seeking to accurately and fully convey his stories of adventure and human psychology.

Joseph Conrad served aboard both sailing ships and steamers for 20 years. He had risen from the lowest rank of crew member to that of captain, when, at age 36, he decided to leave the sea and to pursue a career as a writer.

Friends, literary agents, and publishers expressed doubts upon learning that Conrad—a man who had spoken both Polish and French since childhood, and who had only begun speaking English as an adult—wanted to write in English. Conrad insisted, however, because to him, the English language granted the creative and structural flexibility he was seeking to accurately and fully convey his stories of adventure and human psychology.

Alternative paragraph indicators

And then there are paragraph-indicating solutions that are wrong in terms of the *official* rules of formatting, but also right in terms of simply indicating to readers where paragraphs begin and end. Solutions like these probably shouldn't be used for typical layouts, but they might be good for projects that seem to beg for novel text-formatting treatments.

For one thing, you could let go of the idea of indents or line breaks completely and simply place ornaments within a block of text to denote the beginnings of new paragraphs.

Or, you could alternate between bold and light versions of a font, from paragraph to paragraph.

What about changing the color within a text area every time a new paragraph opens? Two different colors could be used for this approach, as could a much larger palette of hues.

How about applying two or more margin settings to a block of text to delineate paragraphs? You could even come up with settings that result in something like a diamond-like or a pyramidal structure for a layout's text.

Joseph Conrad served aboard both sailing ships and steamers for 20 years. He had risen from the lowest rank of crew member to that of captain, when, at age 36, he decided to leave the sea and to pursue a career as a writer. ❧ Friends, literary agents, and publishers expressed doubts upon learning that Conrad—a man who had spoken both Polish and French since childhood, and who had only begun speaking English as an adult—wanted to write in English. Conrad insisted, however, because to him, the English language granted the creative and structural flexibility he was seeking to accurately and fully convey his stories of adventure and human psychology.

Here, all four of the non-traditional paragraph-indicating techniques shown on the previous page are used together: an ornament is positioned between paragraphs, fonts shift, colors change, and two different styles of justification are employed.

A nicely composed typographic arrangement like this might be put to good use as a standalone word graphic within a brochure or a book, a small-scale informational placard, or a large window graphic outside a gallery display.

Joseph Conrad served aboard both sailing ships and steamers for 20 years. He had risen from the lowest rank of crew member to that of captain, when, at age 36, he decided to leave the sea and to pursue a career as a writer.

Friends, literary agents, and publishers expressed doubts upon learning that Conrad—a man who had spoken both Polish and French since childhood, and who had only begun speaking English as an adult—wanted to write in English. Conrad insisted, however, because to him, the English language granted the creative and structural flexibility he was seeking to accurately and fully convey his stories of adventure and human psychology.

The problem with the text shown above is that it's a little too long to fit neatly within its white box.

Imagine you came across this issue while working on a layout, and that you were not allowed to make the text smaller or reduce its leading. What to do? Five possible solutions are presented on this spread. Keep these solutions in mind since problems like this come up fairly often when adding text to layouts.

198

Joseph Conrad served aboard both sailing ships and steamers for 20 years. He had risen from the lowest rank of crew member to that of captain, when, at age 36, he decided to leave the sea and to pursue a career as a writer.

Friends, literary agents, and publishers expressed doubts upon learning that Conrad—a man who had spoken both Polish and French since childhood, and who had only begun speaking English as an adult—wanted to write in English. Conrad insisted, however, because to him, the English language granted the creative and structural flexibility he was seeking to accurately and fully convey his stories of adventure and human psychology.

For one thing, you could tighten the text's tracking. Here, InDesign's tracking setting was put at -10 (-10/1000 of an em). This allowed the last two words in the lower paragraph to come up a line. Be careful, of course, when reducing the tracking within a block of text. When tracking is too tight, text becomes visually unappealing and difficult to read.

Joseph Conrad served aboard both sailing ships and steamers for 20 years. He had risen from the lowest rank of crew member to that of captain, when, at age 36, he decided to leave the sea and to pursue a career as a writer.

Friends, literary agents, and publishers expressed doubts upon learning that Conrad—who grew up speaking Polish and French and learned English only as an adult—wanted to write in English. Conrad insisted, however, because to him, the English language granted the creative and structural flexibility he was seeking to accurately and fully convey his stories of adventure and human psychology.

The fix done here actually has nothing to do with typographic modifications. In this case, a chunk of text has been edited from the second paragraph. If you really get stuck when trying to fit text within a certain amount of space, you might need to get in touch with the copywriter to see if edits can be made.

Joseph Conrad served aboard both sailing ships and steamers for 20 years. He had risen from the lowest rank of crew member to that of captain, when, at age 36, he decided to leave the sea and to pursue a career as a writer.

Friends, literary agents, and publishers expressed doubts upon learning that Conrad—a man who had spoken both Polish and French since childhood, and who had only begun speaking English as an adult—wanted to write in English. Conrad insisted, however, because to him, the English language granted the creative and structural flexibility he was seeking to accurately and fully convey his stories of adventure and human psychology.

Joseph Conrad served aboard both sailing ships and steamers for 20 years. He had risen from the lowest rank of crew member to that of captain, when, at age 36, he decided to leave the sea and to pursue a career as a writer.

Friends, literary agents, and publishers expressed doubts upon learning that Conrad—a man who had spoken both Polish and French since childhood, and who had only begun speaking English as an adult—wanted to write in English. Conrad insisted, however, because to him, the English language granted the creative and structural flexibility he was seeking to accurately and fully convey his stories of adventure and human psychology.

Another thing you could try is to reduce the width of your font ever so slightly. In this case, InDesign's controls were used to reduce the horizontal scale of the type to 97%—just enough to allow the text to fit within the white box but not enough to cause the font to look notably different than before. Horizontal scaling between 95% and 99% tends to go unnoticed by readers, but anything more than that can make most fonts look strangely altered and/or difficult to read.

And sometimes, a font change (if permitted) is the best solution when it comes to helping text fit within an allocated space. In this sample, the font has been changed from Panno (a face that is slightly condensed by default) to Knockout (a font that comes in a variety of condensed and extremely compressed formats).

Joseph Conrad served aboard both sailing ships and steamers for 20 years. He had risen from the lowest rank of crew member to that of captain, when, at age 36, he decided to leave the sea and to pursue a career as a writer.

Friends, literary agents, and publishers expressed doubts upon learning that Conrad—a man who had spoken both Polish and French since childhood, and who had only begun speaking English as an adult—wanted to write in English. Conrad insisted, however, because to him, the English language granted the creative and structural flexibility he was seeking to accurately and fully convey his stories of adventure and human psychology.

Here, the tracking and the horizontal scaling of the text have been left alone, but the right margin has been nudged outward just a few points. If you can get away with fudging the exact measurements of a column's text, then a solution like this might do the trick when you need to help text conform to a limited amount of space.

SELF-CONTAINED MESSAGES

Callouts, captions, and highlighted text can be used like bait for bigger fish. As in, small bits of text like these can be dangled in front of readers' eyes to draw their attention, engage their brains, and compel their minds to consume the full message of an ad, brochure, or website.

Featured morsels of type can also be sprinkled throughout articles to help clarify and summarize key points—while simultaneously acting as the aforementioned bait to draw readers into the article's text in the first place.

Chances are, you've experienced this yourself. Like when you came across a story in a magazine and—instead of diving straight into its main content—decided to skim through its image's captions before deciding whether or not to read further.

Maybe you even did a similar thing when you first came to this spread—you read through some or all of the callouts surrounding the bright red race car on the facing page before reading the text you're reading now.

Clients don't usually think to ask designers to enhance their layouts with callouts, captions, or featured excerpts. Instead, it's usually the designer who decides, based on experience and communicative savvy, that the layout they're working on could be enhanced by typographic tidbits like these. So keep them in mind—callouts, captions, and highlighted pieces of text—as tricks that you keep up your sleeve for times when the design you're working on could use a boost in its ability to both attract and inform.

Ferrari 156

Designed in 1961
by Carlo Chiti

Powered by a 1.5 litre
190 hp V6 engine

Dubbed the *sharknose*
because of its distinctive
air intake design

The first of Ferrari's
celebrated line of
rear-engine racers

201

Winner of the Formula 1
World Championship in 1961

Callouts

Eight styles of callouts are shown here. Rarely would a designer
choose to present this many kinds of callouts within a single
layout, so don't be mislead by this example. Here, the point is
to provide idea-generating fuel that you can use the next time
you're trying to come up with just the right way of featuring
callouts in a project of your own.

As always, keep in mind the ultimate importance of legibility
when adding text over an image. See pages 152–157 for tips
and ideas about keeping type readable when it's placed
over imagery.

Edible flowers can be grown in your garden right alongside your greens and root vegetables. Use them on salads and as garnish for poultry dishes—and don't forget to save a few for the vase as well.

Edible flowers can be grown in your garden right alongside your greens and root vegetables. Use them on salads and as garnish for poultry dishes—and don't forget to save a few for the vase as well.

Edible flowers can be grown in your garden right alongside your greens and root vegetables. Use them on salads and as garnish for poultry dishes—and don't forget to save a few for the vase as well.

Edible flowers can be grown in your garden right alongside your greens and root vegetables. Use them on salads and as garnish for poultry dishes—and don't forget to save a few for the vase as well.

Edible flowers can be grown in your garden right alongside your greens and root vegetables. Use them on salads and as garnish for poultry dishes—and don't forget to save a few for the vase as well.

Captions

Captions are most often placed below, alongside, or above images. If you're going with a plan like this, make use of your column and/or grid set up (mentioned on pages 208–211) to help guide your placement of captions, and also let your designers' eye direct you toward solutions that add to the overall balance of the page you're working on.

You can set captions using the same typeface as a layout's text (though possibly at a different size or weight, and/or in italic), and they can also be displayed in a font of their own (see pages 138–139 for tips on pairing unalike fonts).

There's nothing wrong with setting a black caption against a white page, but if you're looking to do something different, and possibly add an extra note of connection between a photograph and its caption, try extending a block of color from the image (a color that echoes nicely with the image's hues) and placing your caption inside.

Captions need not always be kept outside photos. If you're working with an image that has an area that can be covered with type (and possibly with a solid or translucent panel behind the type as well), then think through a few different options along these lines.

The sun averages 10 million degrees Fahrenheit at its surface

At the center of our solar system is a yellow dwarf star of modest size—a star that we refer to as the sun. The sun is many times larger than the combined size of all the planets in our solar system (a million earths could fit inside the sun). The sun averages 10 million degrees Fahrenheit at its surface, and nearly 30 million degrees at its core. Compositionally, the sun is about three-quarters hydrogen and one-quarter helium. Traces of heavier elements such as oxygen, carbon, neon, and iron are also present. In simple terms, the sun's heat is produced by a continual nuclear fusion of the hydrogen atoms at its core. This process creates helium and vast amounts of radiating energy—energy that can be seen by human eyes as light, and felt on human skin as heat, 95 million miles away.

At the center of our solar system is a yellow dwarf star of modest size—a star that we refer to as the sun. The sun is many times larger than the combined size of all the planets in our solar system (a million earths could fit inside the sun). *The sun averages 10 million degrees Fahrenheit at its surface,* and nearly 30 million degrees at its core. Compositionally, the sun is about three-quarters hydrogen and one-quarter helium. Traces of heavier elements such as oxygen, carbon, neon, and iron are also present. In simple terms, the sun's heat is produced by a continual nuclear fusion of the hydrogen atoms at its core. This process creates helium and vast amounts of radiating energy—energy that can be seen by human eyes as light, and felt on human skin as heat, 95 million miles away.

At the center of our solar system is a yellow dwarf star of modest size—a star that we refer to as the sun. The sun is many times larger than the combined size of all the planets in our solar system (a million earths could fit inside the sun). The sun averages 10 million degrees Fahrenheit at its surface, and nearly 30 million degrees at its core. Compositionally, the sun is about three-quarters hydrogen and one-quarter helium. Traces of heavier elements such as oxygen, carbon, neon, and iron are also present. In simple terms, the sun's heat is produced by a continual nuclear fusion of the hydrogen atoms at its core. This process creates helium and vast amounts of radiating energy—energy that can be seen by human eyes as light, and felt on human skin as heat, 95 million miles away.

THE SUN AVERAGES TEN MILLION DEGREES FAHRENHEIT AT ITS SURFACE

At the center of our solar system is a yellow dwarf star of modest size—a star that we refer to as the sun. The sun is many times larger than the combined size of all the planets in our solar system (a million earths could fit inside the sun). The sun averages 10 million degrees Fahrenheit at its surface, and nearly 30 million degrees at its core. Compositionally, the sun is about three-quarters hydrogen.

The sun averages 10 million degrees Fahrenheit at its surface

Excerpts

What about pulling certain pieces of information or prose from within a layout's type and featuring it as textual highlights?

Among other things, excerpted text could be placed in a column of its own, added alongside, above, or below a layout's text block, or highlighted through a change in font (and/or color) right where it sits within a piece's text.

And how about presenting an excerpt on a page of its own as either a standalone word graphic or a caption for an image?

Text wrapping text. That's what's going on with the two excerpts shown above. Variations on this theme—with or without the addition of colored backdrop panels—could go in many directions and reach many different ends: The text and its excerpt could appear in the same font, or not; could be the same point size, or not; and could be different colors, or not.

And what happens if you come across an excellent snippet of text within the layout you're working on, want to feature it in some way or another, but can't quite do so because it's simply not written in any kind of standalone syntax? How about calling your copywriter and seeing if you can work together to make revisions to the piece's wording?

To make caramel you'll need 1 cup of butter (plus a little more for greasing your cooking pot and baking dish), a glass of cold water, 1 1/2 teaspoons of vanilla extract, 2 cups of white sugar, 1 cup of packed brown sugar, 1 cup of corn syrup, 1 cup of evaporated milk, and vegetable oil. Begin by coating the insides of a cooking pot and a 9x9 baking dish (larger, if you want thinner caramels) with butter. Set the baking dish aside. Put the glass of cold water and the vanilla extract next to your stovetop since you'll need them while cooking. Add the white and brown sugar to the pot along with the corn syrup, evaporated milk, whipping cream, and butter. Set the pot on your stovetop over medium-high heat and stir the ingredients continuously with a *wooden spoon* until the mixture is smooth and is just beginning to bubble. If you see sugar sticking to the side of the pot, take a plastic spatula and scrape it into the melting mixture. Add the vanilla extract and lower the heat to keep your mixture bubbling minimally. Continue stirring for ten minutes. At this point, test to see if your caramel mixture is done heating by dripping a drop of it into your glass of cold water. Ideally, the drop will form a small ball that holds its shape when it's removed from the water. If this is the case, you're ready to move on. If the drop dissolves when it hits the water, or if it flattens once removed, then continue stirring your heated mixture and test it again in 3–5 minutes. Once the heated caramel is ready, remove the pot from the stove and carefully pour the caramel into your prepared baking dish. Once the caramel has cooled to room temperature, divide it into pieces by making repeated partial cuts with a sharp knife. Apply a light coat of vegetable oil to the blade before each cut to keep it from sticking to the caramel. Line a plate or a container with wax paper (or parchment) and place your caramel pieces on the paper so that they are not touching each other. Store refrigerated. Enjoy.

204

Highlighting text

To close this section on bringing attention to small pieces of text, here are a few highlighting ideas you could apply to one or more words within a block of type.

Some of the methods demonstrated above don't require making changes to the text being highlighted, but rather involve adding color or linework behind or around the selected text. The other methods call upon changes in the text's color, weight, size, and/or font.

Typographic art

How about creating a typographic work of art that you could put up on a wall or post on social media? And what about using a favorite piece of text as subject matter?

You might already have good ideas in mind for a project like this—some saved quotes or bookmarked passages of text in a dog-eared book—or you might need to do some looking for material that resonates with your personal interests and tastes.

The Web, of course, is filled with sources for quotations and excerpts. If you need to find textual material for this project, try doing an online search using words that are connected with a topic or a person of interest, along with the word *quotes*. For example, you could do a search for *cooking quotes, bicycling quotes,* or *Frida Kahlo quotes.* Searches like these can lead to all kinds of potentially useful material.

Start this project by coming up with a target size for your typographic design. Maybe choose a size that fits within an attractive frame you have sitting around somewhere, or a size that will post well on the social media site of your choice.

Next, experiment with as many aspects of typographic presentation as possible: font, type-size, justification, tracking, leading, line breaks, baseline orientation, highlighting, and coloring. Also, think about applying digital effects to your design and possibly adding linework, decor, and/or a backdrop (a solid color, a decorative pattern, an image, or some such).

Work on this one until you love what you've come up with. Be open to setting the project aside for a day or two when you think you have it looking good, and then viewing it with fresh eyes and possibly changing or enhancing certain features. From there, print, post, or otherwise display your typographic creation.

205

LAYING IT OUT

When type isn't being used for standalone designs like logos and signage, it's usually part of a layout. And by *layout*, we're talking about everything from page layouts to web page designs, advertisements, book covers, packaging, signage, and much more.

In terms of sheer quantity, then, type is used in the context of layouts way more than for standalone designs. What this means to you—as a designer who wants to become as proficient as possible with type—is that you need to understand as much as you can about assembling your layouts into compositions that make the most of the type you'll be putting into them.

Composition and aesthetics are covered extensively in this book's Creative Core companion volume, *Visual Design*. Here, a few especially relevant subtopics of these subjects involving columns, grids, linework, panels, and open spaces are addressed.

One overall aspect of composition that's especially important to keep at the fore when working on layouts is visual hierarchy. First talked about on page 134, and mentioned elsewhere in this book as well, visual hierarchy is simply the pecking order of a design's components: what catches the eye first, second, and right on down the order. Strong visual hierarchy provides the eye with a clear sense of navigation through a design; weak visual hierarchy can lead to a mushy and indecisive look.

As you're reading about columns, grids, linework, panels, and space in the pages ahead, and when you're actually applying these kinds of things to your layouts, keep visual hierarchy strongly in mind. Increase it to improve notions of organization and to raise feelings of energy (from mild to extreme—depending on the degree of hierarchy employed), pull back on it to limit these projections, but never let it just happen by default or by chance.

206

Levels of hierarchy

Two book cover designs. Same words, same image, two very different presentations. Both could be considered good solutions, and it would be up to you, the client, and/or marketing minds to decide which connects best with the book's content while also standing the strongest chance of impressing its target audience.

From a design standpoint, the main difference between these two covers (apart from their obviously different use of type) is their presentation of visual hierarchy. The design on the left gives the eye an active and energetic range of hierarchical levels to consider. The design on the right comes across far more static and reserved. The lesson? Make visual hierarchy happen, and happen clearly—regardless of its strength.

Columns

Columns give type neat and logical places to reside while adding a sense of order and functionality to layouts. No doubt you're already well acquainted with columns, so here are just a few reminders about using them.

Simply put, the right number of columns for a layout is that which looks the best and results in lines of readable and easy-to-navigate type. Ideally, as mentioned on page 188, a column's line will hold between 45 and 75 characters (not a written-in-stone mandate, but it is a good range to aim for). The number of characters in a column's line is affected by font choice, font size, column width, and text tracking.

When working with columns, keep an eye on the gutters (a..k.a. *the spaces*) between them as well. Too little space between columns can cause readability issues; too much space tends to make layouts look clumsy and disjointed. Let your eye tell you what's right and also whether or not you should add thin lines or rows of dots between your columns (as seen on pages 212–213) to help them stand apart from each other.

Flexibility

At top is a blank page with only its column guides showing. Below it are three examples of how these column guides might be put to use for a magazine article.

You'd hardly know that all three of the layouts have exactly the same underlying guides, and it just goes to show how far and wide designer can—and often should—look when deciding how to make use of the columns that support their layouts.

Same goes for grids. Grids can be interpreted and put to use in practically endless ways—as is discussed on the next spread.

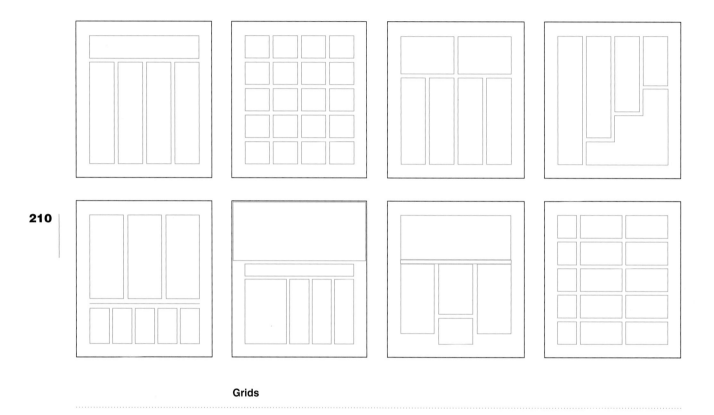

Grids

Grids are sets of guidelines that provide visual cues for the placement of a layout's components—including headlines, text columns, imagery, and open space.

Designers often use grids to help establish a cohesive look between pages of a book, magazine, or website. You can set up a layout's grid using guidelines within programs like Illustrator, InDesign, and Photoshop. Use the grid to position visual elements as you work, and turn it off whenever you want to see things as they'll actually look when a piece is printed or posted.

Grids are a very big topic, by the way. Much too big to be covered on this spread alone. Consider looking into books that cover the subject in depth and provide plentiful examples of how different kinds of grids can be established and used.

Adhering

Overruling

When setting up a grid, or when following a grid that's already been designed by yourself or someone else, decide (or find out) whether or not the grid is to be followed strictly.

In the sample above, a grid's guideline's have been followed very closely: The headline, columns, and decor have each been put in place exactly where the grid says they're supposed to go.

Grids are sometimes intended to provide suggestions more than they're meant to lay down the law. Here, a layout's underlying grid has been interpreted with more artistic freedom than in the previous example. The grid still provides the design with a look of structure, but has been overruled in places so that the layout assumes a more casual feel (this being a fairly modest example of grid defiance—things can go much further afield if you or the art-director-in-charge allows it).

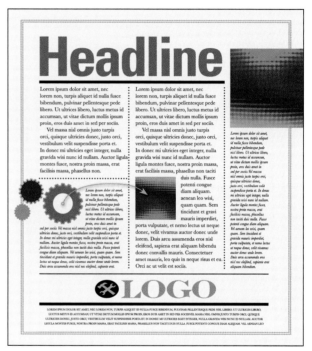

Assistance from lines

It's rarely an absolute necessity to add linework to a layout, but sometimes it's just the thing needed to connect with current trends and/or to help with the organization of a page's type and imagery. Lines can be used to mark divisions between columns, to help set a headline apart from other components of a layout, to border a design, and to help direct attention from one visual element to another (as demonstrated by the arrow-capped line in the sample at right).

Linework can be used sparingly or abundantly, and, among many other things, linework can be thin, thick, dashed, dotted, doubled, neat, or rough. Keep an eye on trends in design and you'll notice that linework—like typography and color—is subject to trends: Certain specific styles of linework are always coming and going from favor.

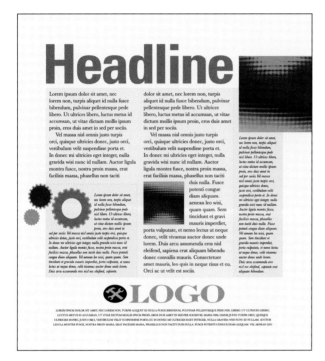

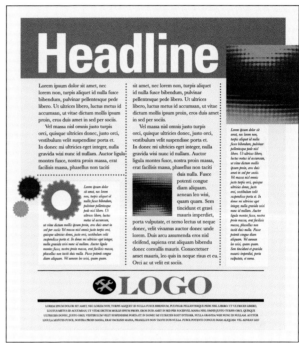

Panels, too

You can also employ panels to add notes of style and/or structure to a layout's words and images. Background panels can be: used with or without linework; darker or lighter than the type they sit under; black, white, or colored; plain or patterned; few or many.

Protect your type's legibility by maintaining sufficient differences in value (also talked about on page 152) between text and backdrop panels. And, if value differences aren't quite doing the trick, then consider presenting your type bigger and/or bolder as well.

A tip: When reversing small and/or fine type from a colored panel, make sure your panel's color is built from only one or two of the four CMYK inks. The more inks involved, the greater the chance that registration issues will cause some of the reversed areas to fill in.

214

The spaces around

Type can be enclosed by linework, decorations, imagery, and the de facto edges of a piece of paper or a web page. Whatever the case, always take the time to specifically consider the spaces *around* your layout's text. Not enough space can make type feel claustrophobic and uninviting. Too much space, in some cases, can make type appear lost and abandoned.

Evaluating space(s), like so many other things we do as designers and artists, is mostly instinctual work. If you have doubts about the amount of space you're leaving around your type, look at a few options and let your art sense tell you what's best.

Also, there are times when unequal spaces around a page's text might turn out to be an attractive option. In the past, books commonly presented their page-by-page text within creatively and asymmetrically positioned blocks, as exemplified above.

Take a look at the spaces around the text in this sample. See how each is a different width? Unequal spaces like these can add to a layout's feeling of energy and interest—inferences that are sometimes desirable or sometimes simply not called for. Again, call upon your creative savvy to help you decide whether or not to take advantage of conveyance-producing details like this.

There is an area
beyond Earth's
atmosphere that
is so vast, and so
predominantly
void of any form
of matter, that
it's simply called space.

Some messages beg for
a minimalist presentation
within fields of emptiness.
Messages like the one
above, for example.

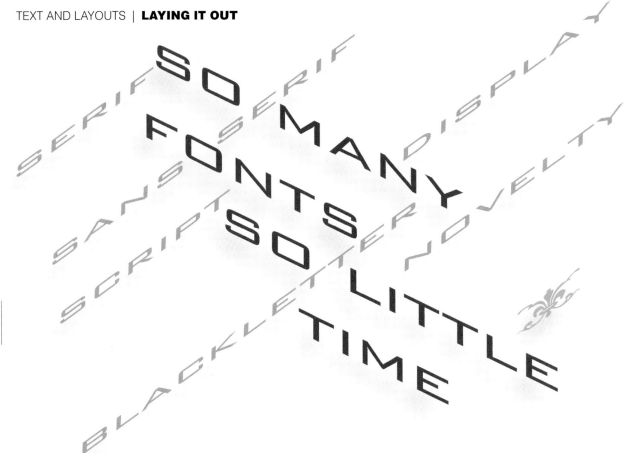

216

Full page, purely typographic visuals

It's not often that designers get asked to design full-page, purely typographic visuals. Which is why many designers don't wait to be asked. They just go ahead and design a visual using nothing but type, add it to a page within the booklet, brochure, or magazine they're working on, and hope that the decision-makers will be convinced by what they see.

Begin full-page typographic compositions the same way you would begin working on any illustration or graphic—by brainstorming thematic directions, making thumbnail sketches, going through your font menu in search of potentially useful typefaces, and then putting things together on the computer once you're ready.

Be open to changes of direction as you work, too. You might, for example, struggle for some time with a certain creative approach, only to realize that switching to a bolder, lighter, more condensed, or completely different font will make things happen much easier. Or you might suddenly notice a different way of stacking the words of your design so that ascenders and/or descenders fall together more neatly than before.

Finalize your design by applying color, and possibly by employing look-altering digital effects (like the subtle textural effect in the sample opposite, for example).

so many

fonts

so little

time

serif

sans serif

script

blackletter

monosp

DISPLAY

So many

On the fly

Most designers and illustrators, most of the time, believe in the idea of starting out with thumbnail sketches before really diving into a complex illustration or graphic. Sometimes, though, it really is best to just turn on the computer, open Photoshop or Illustrator, and start piling things together, layer by layer and effect by effect. That's how this typographic montage was created—spontaneously and intuitively. Not only can this approach work for real-world design projects, it's also an excellent way of exposing yourself to your computer's typefaces and software through a just-for-fun creative project.

so little
time

fonts

DISPLAY

monospace

blackletter

script

sans serif

serif

Throughout this book are suggestions about expanding your awareness of—and proficiency with—typography. Here, all on one spread, is a collection of resources that you might want to regularly investigate to keep your typographic skills and know-how up-to-date and growing.

220

More books

Lessons in Typography, of course, is just one book on typography—and one that can't claim to cover nearly the whole of this vast topic. Ask other designers about their favorite type books, see what people are buying on Amazon, and buy or borrow books that explain and demonstrate a wide range of topics related to typeface design and the presentation of typographic material.

Used books

Been to a used bookstore lately? Not all used bookstores have a good supply of design-related titles, but some have entire shelves, sections, and even rooms devoted to various aspects of art and design.

Archival design

Looking backwards helps us connect the dots, so to speak, and gain a clearer picture of how trends in design move forward. Older books on design (possibly found in used bookstores) can be an excellent source of archival typographic examples. Do a search for websites that include material of this kind of thing, too, when looking for historical samples of design as a whole and typography in particular.

Websites

Since most designers look to the Web when investigating or purchasing typefaces, nearly all typeface companies (or font foundries, as they're often called) commit themselves to a strong online presence. Find a few foundries that you particularly like—as well as a handful of for-free font sites—and set yourself up to receive email notifications of their new releases, late-breaking news, and sales.

Other designers

Very, very importantly, maintain your connections with other designers and make it known that you want to hear about their favorite typefaces and where they go to get them. Keep an eye on the work of other designers, too, and learn from both their typographic successes and failures. Also, consider seeking skilled professional peers when you're in need of advice or a critique involving design projects of your own.

Annuals

There are several printed annual publications that highlight great works of design and typography. Make a priority of following at least one or two of these annuals throughout the year(s). There are few better ways to keep tabs on how great designers are using type, and also on the typographic trends that influence their work. (Keep these annuals on coffee tables and easily accessible bookshelves, too, and make a habit of thumbing through them regularly to help maintain your sharp sense of typographic awareness).

Saved examples

Your own collection of saved examples of great typography is also an excellent source of ongoing inspiration and education. You are keeping a file of great examples of typography in a file folder (digital or actual)... aren't you? If not, start. Take photos and screen grabs of intriguing and attractive examples and save them for future reference.

Practice

And finally, practice itself is an outstanding and essential source of typographic learning. There's no substitute for experience. Whenever you work on a design project, make a point of pushing your typographic skills as far as the project will allow; taking your skills into new creative realms whenever possible; and looking for new ways of fine-tuning every aspect of your typographic know-how with each and every job you work on.

APPRECIATION

This is it, the final spread in *Lessons in Typography* (before the glossary and index begin, anyway). And here, things wrap up pretty much where they began on page 12 with a prompt toward an ongoing and habitual effort to build and maintain a true appreciation for all things typographic.

Typography is a form of art that usually presents itself through the larger and more commonly recognized visual venue known as graphic design (or simply, *design*). Being its own form of expression, it's almost surprising that more galleries aren't filled with gorgeous examples of typographic characters and typefaces. (But even so, typography can't really complain for lack of exposure since few, if any, forms of art are represented as often or as widely as the characters of typefaces.)

In any case, think of your brain as its own gallery of exquisite works of typographic art, your eyes as the gatherers of this gallery's aesthetically superb specimens, and your art sense as both the curator and perpetual *enjoyer* of your collection.

So, keep your eyes wide open for both old and new examples of typographic brilliance and innovation. Avoid falling into the habit of simply reading the titles at the beginning of movies, the headlines in the advertisements you come across, and the text of the articles you look at. Read these things, yes, but also make it a routine to note the typefaces you're seeing.

Not every font you come across will impress or excite you, but when you do find one that does, dive into it with your eyes and brain and figure out just what it is about its characters and its characteristics that turn you on. Maybe take a screen grab or snap a photo of what you've found and save the image in a folder on your hard drive for future reference.

Appreciate type. Always, and deeply. It's a source of creative enlightenment that never runs dry.

m	%	**4**	Y
2	*fi*	*	**W**
g	Q	@	§
K	{}	**i**	+
z	*e3*	**$**	×
8	▫	ℬ	e
,,	A	❧	⌐

224

Glossary

GLOSSARY

Note: The definitions provided here are given within the sense of how these terms are used within this book.

Ampersand

A symbol that stands for the word *and*.

Arm

The horizontal or diagonal stroke of a character that does not connect to another stroke at one or both ends.

Ascender

The vertical stroke of some lowercase letters that extends above the typeface's x-height line.

Baseline

The guideline upon which a typeface's characters sit.

Blackletter

A style of typefaces designed according to the heavy, angular, and condensed calligraphic method of writing prevalent during the 13th through 15th centuries. Also known as *Gothic* or *Old English*.

Bowl

The enclosed rounded part(s) of a letter, as seen in characters like the uppercase P and B, and the lowercase d and q.

Brush script

A casual style of script typefaces that emulate the look of letters written by hand using ink and a brush.

Calligraphic script

A more formal style of script typefaces that replicate the look of calligraphic writing done with a broad-tipped pen or brush.

Callout

A brief caption or notation related to a key point of a photo or an illustration. Callouts are often connected to their subject with an arrow or a line.

Cap-height line

The guideline that establishes the height of a typeface's capitals and ascenders.

Capital

An uppercase letter.

Caption

A short passage of text usually related to the content of a photo or an illustration.

Case configuration

The way in which case has been applied to a word or a group of words. The three main case configurations are: all uppercase, all lowercase, and inital cap (first letter is capitalized and the rest are lowercase).

Centered justification

Lines of text that are centered along a vertical axis.

Character

Any member of a typeface—letter, numeral, punctuation mark, or symbol.

Column

A rectangular container for text, usually vertical. Layouts often feature between one and five columns of text.

Counter

The space within a closed—or partially closed—part of a letter. The lowercase e demonstrates both a closed and an open counter—closed in its top portion and open in its lower.

Cross stroke

A horizontal stroke that intersects the stem of a lowercase t or f. A *cross stroke*, unlike a *crossbar*, connects with the rest of its letterform at only one—or neither—of its ends.

Crossbar

A horizontal stroke that connects on each end with a stroke or a stem. The uppercase A and H feature crossbars, as does a lowercase e.

Descender

The part of a lowercase letter that extends below its baseline.

GLOSSARY

Dingbat

A typographic symbol, ornament, or illustration. Some dingbat fonts are heavy on symbols, and others contain mostly ornaments or imagery.

Display font

Expressive fonts that are meant to be used for headlines and word graphics. Serif and sans serif fonts that have been expressly designed for use at larger sizes are also sometimes called display fonts.

Dot matrix font

A font specifically designed to print well using a dot matrix printer. Even though dot matrix printers are rarely used these days, certain dot matrix fonts remain in use, Chicago and New York among them.

Drop capital

A large capital letter used at the beginning of a paragraph. Drop caps (as they're also known) are usually sized so that they drop down two or more lines into a paragraph.

Ear

The small detail extending from the upper bowl of a serif-font lowercase g (as seen in the large sample on page 13).

Em

A flexible unit of measure that equates to the size, in points, of the type being used.

Eye

The closed counter of a lowercase e.

Flush left justification

Lines of text that are vertically aligned along their left edges. The right edge of a flush left column of text is allowed to be ragged.

Flush right justification

Lines of text that are vertically aligned along their right edges. The left edge of a flush right column of text is allowed to be ragged.

Font

A specific style of type within a typeface family. See the final paragraph on page 14 for a bit more on how the words *font* and *typeface* are used in this book.

Glyph

A symbol, ligature, or alternate typographic form within a typeface. Glyphs can be accessed through pull-down menus in InDesign and Illustrator.

Grid

A set of reference guidelines that can be used to generate cues for the placement of a layout's components.

Gutter

The space between columns.

Hairline stroke

The thinnest stroke within typefaces that feature strokes of different widths. Nearly all serif typefaces feature a hairline stroke and a thicker stroke.

Illustrator

An Adobe program that specializes in the creation and handling of vector-based graphics.

InDesign

An Adobe program primarily used to create layouts for both print and the Web.

Initial cap

A case configuration where only the first letter of a word is capitalized and the rest are lowercase.

Italic

A forward-leaning style of typeface, often with hints of cursive lettering. Most italic fonts are paired with non-leaning, *roman* versions of the font. See also *Oblique*.

Justified text

Text that fits within a column with both its left and right edges conforming to a vertically aligned edge from line to line.

GLOSSARY

Kerning

The space between pairs of letters within a word.

Leading

The distance between the baselines of stacked lines of type. Leading, like type, is measured in points.

Ligature

Two or more letters that are joined together to form a single glyph.

Lowercase

Non-capital letters of a typeface.

Monogram

A standalone configuration of one, two, or three (and sometimes more) individual letters.

Monospace

A kind of typeface whose characters all fit within the same horizontal measurement. Monospace fonts were primarily developed for typewriters and early computers.

Novelty

A style of typeface that doesn't fit easily into any other category of type. Novelty fonts are sometimes highly decorative, sometimes built around peculiar themes, and sometimes made to look damaged or deranged. Good for certain logos and headlines, novelty fonts are almost never a good choice for text.

Oblique

Many sans serif fonts use oblique letterforms rather than true italics for leaning letters. The difference is that italics conform to certain aspects of cursive writing, while obliques are just forward-leaning relatives of their upright counterparts. See also *Italic*.

Ornament

A decorative typographic design—often found in dingbat families of type and sometimes as extended offerings of regular typefaces.

Orphan

A solitary word left over at the end of a paragraph. Usually something to be avoided.

Photoshop

An Adobe program designed to enhance and modify pixel-based images. Many art professionals also use Photoshop to create illustrations.

Point

A unit of measurement equal to 1/72 of an inch.

Reverse

To allow an element of a printed piece (type, linework, decorations, and the like) to appear as the paper color within areas of ink coverage. White type, for example, has been reversed when it appears within an area of black or colored ink.

Roman

The upright version of a typeface—as opposed to its leaning *italic* or *oblique* version.

Sans serif

A style of type without serifs. Helvetica, Univers, and Futura are sans serif fonts.

Script

Typefaces that generally mimic traditional cursive letterforms that would be drawn with a quill or a metal-nibbed ink pen.

Serif

Projections (usually small) that finish off the main strokes of a serif typeface's characters. See page 23 for examples of different kinds of serifs.

Serif typeface

A typeface that has serifs. Serif typeface characters are almost always composed of thick and thin strokes. See page 23 for a look at the four different kinds of serif typefaces.

GLOSSARY

Shoulder

The curved stroke that comes down from a stem.

Small caps

An alphabet of all uppercase characters. In place of its lowercase letters, a small caps alphabet uses slightly smaller capitals.

Spine

The main curved stroke of an S (both uppercase and lowercase).

Spur

A small projection that comes off a main stroke, though not a serif or an ear. Both serif and sans serif fonts can feature spurs (see the large type sample on page 26 for a look at the spur that surprisingly appears on a lowercase Helvetica a).

Stem

The full-length vertical stroke of characters like an uppercase T and B, and a lowercase d and l.

Stroke

A widely used term in typography that collectively refers to straight and curved parts of letters like stems, arms, and bowls.

Tail

A term that always refers to the lower stroke of a capital Q (whether the stroke is plain, curved, or decorative). *Tail* is also sometimes used to refer to the descending stroke of a capital K and R—details that can also be called *legs*.

Target audience

The specific demographic being aimed for with a commercially purposed work of design or art.

Terminal

The end of any stroke that doesn't include a serif. One kind of terminal, a *ball terminal* (a roundish feature that usually connects gracefully with a thin stroke), is sometimes seen at the end of the curved stroke of a lowercase r, or on both the upper and lower ends of an italic lowercase f (examples of both of these things can be seen in the word *giraffe* on page 17).

Text block

An area within a layout that contains one or more columns of text.

Thumbnail sketch

A sketch—usually small and quickly drawn—that represents an idea for a layout, a logo, an illustration, or any other work of design or art.

Tittle

The dot of a lowercase i or j. Most tittles are round or oval, but some take on other shapes.

Tracking

The relative spacing allowed between the letters of words within an area of text.

Typeface

The umbrella term for an overall typographic design—including its light, medium, or heavy weights, its italicized versions, and its condensed or extended alternatives. See the final paragraph on page 14 for more on how the words *font* and *typeface* are used in this book.

Uppercase

Another term for a capital letter.

Value

The darkness or lightness of a color on a scale that goes from near black to near white.

Visual hierarchy

The apparent visual priority of a composition's elements. A strong sense of hierarchy occurs when on element of a composition clearly stands out above the piece's other visual components.

Weight

The relative thickness of a font. A light weight font will have thinner details than the same font in a regular, bold, heavy, or black weight.

X-height line

The line at the height of a typeface's lowercase letters—based on the height of its lowercase x.

Index

INDEX

INDEX

Answers to quiz on pages 20–21:

1. Crossbar
2. Tittle
3. Tail
4. Shoulder
5. Serif
6. Stroke
7. Hairline stroke
8. Closed counter
9. Cross stroke
10. Cap-height line
11. X-height line
12. Baseline
13. Leg
14. Open counter
15. Spur
16. Ascender
17. Bowl
18. Descender

The **New Riders Creative Core** series provides instruction on the fundamental concepts and techniques that all designers must master to become skilled professionals. Taught in Jim's own down-to-earth, offbeat style, each book presents essential principles of design and art through equal parts text and images that visual learners will love.